Outdoor Photography
101 Tips and Hints
Heather Angel

D0963856

Outdoor Photography
101 Tips and Hints
Heather Angel

SILVER
PIXEL
PRESS

Outdoor Photography: 101 Tips and Hints

Published in the United States of America by
Silver Pixel Press®
Division of
The Saunders Group
21 Jet View Drive
Rochester, NY 14624
Fax: (716) 328-5078

ISBN 1-883403-41-3

Layout by Buch & Grafik Design, Günther Herdin, Munich
Printed in Germany by Kösel GmbH, Kempten

Contents

Preface

Successful photography stems more from having a perceptive eye than a camera with a high price tag. Close behind come the ways and means of solving problems—often by putting inexpensive accessories to work. This book draws on my experience of having worked in varied climates—from the poles to the tropics—over more than two decades. While many of the ideas presented are the result of resolving my own predicaments and even crises, some were promoted when participants at my photo workshops revealed the contents of their gadget bags or during trips I have shared with other photographers. To everyone who contributed directly or indirectly, I extend my grateful thanks.

The original list of tips and hints proliferated way beyond my assigned limit. Even with the exclusion of those associated with highly specialized techniques such as high speed flash and aerial and underwater photography, which are all beyond the scope of this small book, tough editorial decisions had to be made. What is left, inevitably reflects the way I work out in the field, and hopefully these tips may help many a reader out of a sticky situation. All have been tried and tested outside.

My own philosophy has always been to share my experiences, which have in turn been enriched by others. I have been criticized by other British wildlife photographers for being too generous in passing on my tips and hints. What a blinkered approach! Photography is so subjective that it is not difficult for each individual to develop his or her own "style," which stems from that seeing eye. Without that, no amount of equipment or gadgetry can make up for an imperceptive eye.

I should like to thank John Clements, who read and commented on some of these tips, and most especially Valerie West, who deciphered and converted my hand-written notes (often produced after a long flight) into an immaculate manuscript. My husband, Martin Angel, has been a constant source of encouragement over so many years, a useful springboard for bouncing off ideas, as well as an invaluable assistant—in both the creation of gadgets and their use in the field. Our son, Giles, cheerfully assisted with special photography of some gadgets described in this book, while Penny Howell and Lindsay Bamford both gamely posed as my field assistants. My thanks to you all for your much-valued contributions, which have helped to make this book a reality.

Note: Any photos of captive-bred animals reproduced herein have been designated with a (C) in the caption.

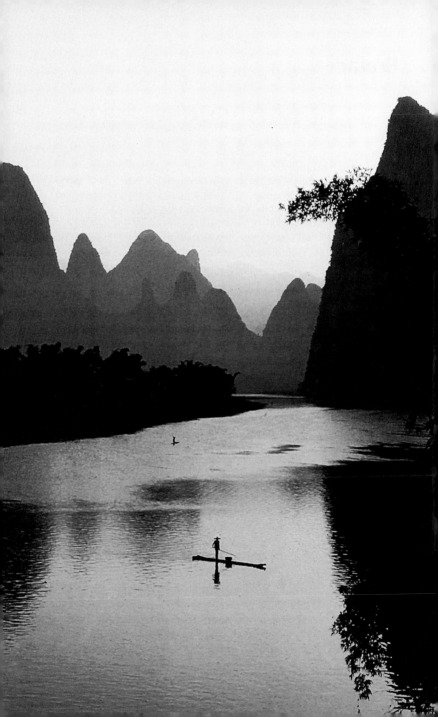

TIPS AND HINTS
FOR PLANNING TRIPS

1 Keep a Multi-Year Diary

Many events in the natural world occur over a limited period, so if they are missed, you will have to wait another year to capture them on film. Knowing when a particular plant is likely to bloom or when animals will congregate to feed or migrate is therefore essential to helping any outdoor photographer plan the year ahead and ensure success.

Anyone who has a keen pair of eyes and is a good field naturalist will soon get to know the sequential events that take place in his or her vicinity. Knowledge accumulated over the years will also provide insight into predicting when an abnormal weather pattern will result in a season arriving earlier or later than usual. Latitude and altitude also affect the timing of the seasons. For example, spring comes later with increasing latitude (the farther north you go in the northern hemisphere or the farther south in the southern hemisphere) and also with increasing altitude (the higher you progress up a mountain, the colder it becomes, keeping plants dormant longer and delaying the arrival of spring).

But being able to accurately predict the timing of worldwide wildlife spectacles is quite another matter—unless you have a network of international contacts. For this reason, I compile my own multi-year diary in which I enter key events not only from

◀ **Planning and preparation were essential to ensuring that nothing was left to chance for taking this dawn shot of the Lijiang (Li River) near Guilin, China. We left our riverside hotel at 4:00 a.m. and took a chartered boat (towing a bamboo raft) upriver, where we climbed a hill.**

my own and other biologists' or photographers' observations but also nuggets of information gleaned from articles, books, or TV programs. If you have the time to browse, there is also a host of information available on-line via the World Wide Web.

Conventional five- and ten-year diaries are not large enough to include articles or pictures clipped from magazines, so I use a loose-leaf ring binder with items filed month by month. Each new item is briefly listed on a cover sheet under the respective month. In this way I can see at a glance that if I want to focus on polar bears in Canada in November, this will coincide with the time when emperor penguins have young chicks in Antarctica.

Once the subject and prime location have been chosen, the appropriate period is then blocked onto a large yearly wall planner (to make sure I don't accept any lecturing commitments during this time). As the departure date nears, I make a few calls to fine-tune the optimum period depending on whether the season is early or late.

2 What to Know Before You Go

Taking time to check out a location beforehand, either by reading a reputable field guide, looking at maps, or, better still, talking to naturalists who know the site, will ensure that your time in the field is maximized. Checking out if a nature reserve or park has restricted access and whether a permit is required will save you from making a wasted journey.

Learning to read various types of maps will give you a distinct advantage. Topographical maps enable you to plan your routes, whether it be finding a speedy access or a more leisurely, winding scenic route. They also reveal different habitat types (wetlands, mountains, grasslands, or forests) as well as pinpoint higher ground so you can gain a better overview across a flat landscape. If you want to discover where a particular type of rock, such as limestone, outcrops, then a geological survey map is a must.

Maps are infinitely more useful when I can find someone who knows the area to mark up the best viewpoints or wildlife sites

beforehand. (However, beware of birders with powerful binoculars advising a good birding location, because they are invariably overly optimistic about the minimum focusing distance!) Immediately after a field trip, I make my own marginal notes on the maps using line pointers to link them to the site.

Whenever I visit a new location and my time is limited, the first thing I do is to buy postcards of local views, preferably those with captions (otherwise you will have to ask from where the view was taken). This ensures that I get to the best viewpoints as quickly as possible—not so I can mimic existing views, but so I have plenty of time to work out the best viewpoint, lens, and time of day for my own shot. Then I mark the direction of the view with an arrow on a map and jot down the optimum time of day in the margin.

3 Check Temperature Extremes

Over the years I have worked in highly variable weather conditions with temperature extremes ranging from more than 95° F (35° C) in India to below –22° F (–30° C) on the main Antarctic continent.

When planning to work in hot or cold climates it is essential to know what weather extremes you are likely to encounter—not only to ensure that you have the correct clothing, but also that your equipment will function. There is nothing worse than being too hot or too cold when working on location. You become so obsessed with your body temperature, your photography inevitably suffers because you cannot concentrate 100%.

If you are traveling with a reputable tour company specializing in wilderness or outdoor trips, the operator should be able to provide you with accurate information on the average daytime and nighttime (important if you are camping) temperature range for every destination to which they run tours. However, when making your own travel plans, you will need to do some homework. Travel guide books and travel agents are excellent sources for weather facts and figures. Many agents have access to a

weather database, and they can fax you a detailed printout of pertinent information within seconds.

An invaluable book for everyone who frequently travels to different locations is *The World Weather Guide* by E. A. Pearce and

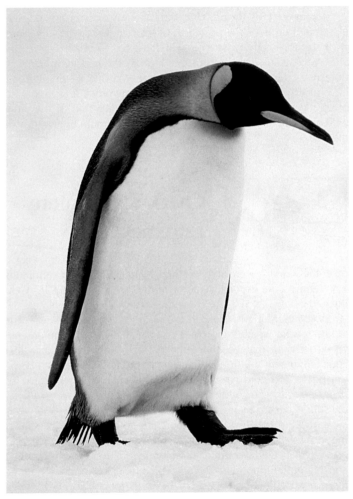

Before leaving on a trip to South Georgia, Antarctica, I checked out the temperature extremes I was likely to encounter. However, unlike my camera, this king penquin didn't mind the cold.

C. G. Smith published by Hutchinson & Co. in London, England (second edition, 1990). In addition to giving a general synopsis of the weather for each country (listed alphabetically and by continent), it has tables that give the average as well as the minimum and maximum monthly temperatures (in both °F and °C), the relative humidity, and precipitation for key locations. The authors point out, for instance, how our bodies can tolerate dry heat much better than the damp heat associated with highly humid conditions. They also stress and illustrate how wind chill is a function of decreasing temperatures *and* increasing wind speed.

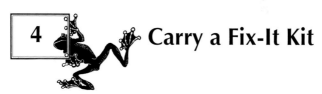

4 Carry a Fix-It Kit

You have flown thousands of miles, driven some more, and trekked the rain forest while enduring fire ants, but your efforts are rewarded as you come upon an orangutan under a dark canopy. As you begin to set up, you envisage the way the picture will appear on a magazine cover. You connect the flash to the camera and release the shutter, only to find that the flash fails to fire. The orangutan disappears up into the canopy, and with it, your award-winning photo. The last thing you want is to miss a shot simply because some part of your equipment needs a quick or simple repair!

Over the years I have devised a fix-it kit that now remains in an OutPack® Minipack fixed either to my photo pack or waist belt. This kit has baled me out of many a sticky situation. It includes:

❏ Jeweler's screwdrivers
❏ A set of different-sized Allen wrenches
❏ Contact cement
❏ Spare parts (screws, springs, knobs, etc.) for my tripod, quick release, flash bracket, and other equipment—all in clearly marked tiny plastic bags
❏ A small coin to rotate the screw that recocks a Hasselblad® between-the-lens (leaf) shutter
❏ Adhesive putty
❏ Adapter bushing for converting a 3/8" to a 1/4" hole

My fix-it kit is always at hand, having baled me out of many sticky situations.

❏ Rubber bands (Pack extra for shooting in sub-zero temperatures—you'll need them to secure exposed roll films when it's so cold that saliva freezes.)
❏ Battery tester
❏ Safety pins or metal paper clips (see Tip 55)
❏ Roll of black electrical vinyl or gaffer tape (for taping over a hole in the camera or flash, or for securing a wobbly remote flash connection)
❏ Color print film (see Tip 14)
❏ Flashlight (for working at night)

5 Make a List and Check It Twice

How often have you arrived at your destination only to find you have forgotten some crucial item—one that's essential to your own survival or comfort, or one that simply makes your work easier? To avoid these nightmare situations, in addition to my fix-it kit (see Tip 4), which never leaves me or my photo pack, I have compiled my own clothing and photo accessory checklists for working in specific habitats. These are printed out, stuck onto 5 x 8-inch filing cards, and updated frequently. No doubt, photographers will want to compile their own personal lists. The examples below can be used as a basis on which to make your own modifications.

I have omitted camera equipment, since this depends on your subject goals, how long you intend to work on location, whether you employ an assistant to help carry gear, etc. However it is worth listing your equipment for each trip (take several copies) just in case it is needed for overseas customs. DO NOT show it unless absolutely pressed, because it will involve much form-filling and delays upon your arrival and departure.

GENERAL LIST
❏ Plastic sheet or trash bag (to protect equipment on wet or snow-covered ground)
❏ Field notebook (see Tip 15)
❏ Self-adhesive numbered labels (see Tip 13)
❏ Kodak® 18% Gray Card
❏ Film leader retriever
❏ Swiss army knife
❏ Filter wrench

TROPICAL RAIN FORESTS (See Tips 63–66)
❏ Waterproof insect repellent
❏ Compass
❏ Whistle

- ❏ Airtight picnic boxes with indicator silica gel crystals in cotton bags to keep film dry
- ❏ Plastic shower cap
- ❏ Waterproof custom-made camera and lens covers (Camera-mac© or Laird®)
- ❏ Head and wrist sweat bands
- ❏ Water bottle
- ❏ Alcohol-based permanent marker (to label 35mm cassettes)
- ❏ Waterproof notebook and pencil for use in rain
- ❏ Waist pouch for spare gear
- ❏ Self-sealing, zipper-type plastic bags
- ❏ Waterproof tape to protect flash connections
- ❏ White or clear plastic umbrella (to protect camera on tripod from rain)
- ❏ Waterproof camera case, such as one made by Pelican; or large whitewater stuff sack with straps for keeping photo backpack dry in torrential rain; or poncho to cover photo backpack
- ❏ Absorbent towel such as a Packtowl®
- ❏ Jungle boots or hightop basketball shoes (to protect ankles from leech bites)
- ❏ High-legged fine cotton socks (also to prevent leech bites)
- ❏ Tape or string for tying back branches

POLAR REGIONS (See Tips 67–71)
- ❏ Remote, cold-weather battery pack
- ❏ High-energy lithium batteries
- ❏ Tri-Pads® to insulate tripod legs (or foam tubes used for pipe insulation)
- ❏ Sunglasses to reduce glare from snow and ice
- ❏ Homemade thermal camera jacket
- ❏ Thermometer on key ring fixed to gadget bag
- ❏ Chemical handwarmers
- ❏ Plastic sled with elasticized bungee straps for transporting equipment over ice and snow
- ❏ Self-adhesive rubberized strips for insulating the focusing ring on long lenses

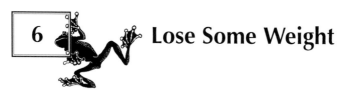

6 Lose Some Weight

Climbers are adept at pruning down the weight they carry—after all, their life may depend on it. Whether packing your checked baggage for an international flight or your camera bag or photo pack for a day trip, it is worth economizing on weight—if only to enable you to carry yet more rolls of film. For a long-haul trip, I jettison all film packaging (this saves me 0.4 oz. [12 g] per roll and 42 oz. [1200 g] on 100 rolls). I then estimate the daily film quota and carefully pack the film into individual self-seal plastic bags

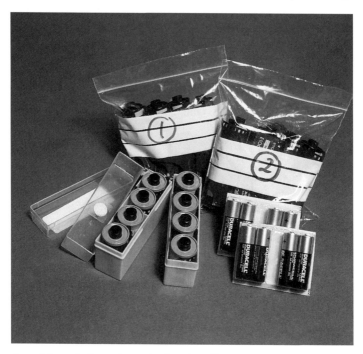

In outdoor photography and when traveling, every ounce counts. By cutting off or tossing out most of the packaging that comes with battery and film stock packs, you can reduce surplus weight substantially.

marked with sequential numbers for each day traveled. In this way I can readily see whether I am over- or under-shooting my estimate. It is always prudent to include more film than you expect to use, because even if you can purchase your favorite brand, it is very unlikely it will be from the same emulsion. On short trips I use the upright plastic boxes measuring 54 x 108 x 30 mm in which some processing labs return 35mm mounted slides. Four 35mm rolls fit perfectly into one box, and several boxes can be conveniently carried in a photo vest.

One word of caution: Resist being lazy and simply chucking the naked film cassettes into a large plastic bag. I did this once, only to discover the corners of the film cassette lip scratched some of the black non-conducting squares on the DX-coding panel, thereby resulting in the camera "reading" an incorrect film speed. This was apparent only when fitting a Nikon SB-24 flash to my F4 camera. I knew I had loaded ISO 100 film, yet the flash LCD panel recorded ISO 200—one stop more speed, which would have resulted in one stop underexposure!

The problem with electronic cameras and flash units is that they eat up batteries. If I opt not to take a battery pack (see Tip 56), to save weight I cut down the cardboard packaging surrounding the AA batteries, and when working in temperatures well below freezing I use lithium batteries. These weigh in at only 0.25 oz. (7 g) each compared to the 0.56 oz. (16 g) of an alkaline battery, *and* they have the added advantage of functioning in temperatures as low as –4° F (–20° C).

7 Battery Alert!

Travelers should be aware of the strange anomaly as regards transporting batteries on airplanes. Since the Lockerbie air disaster in Scotland, batteries can no longer be carried in any checked baggage when flying from London airports. I know this from experience, since I was once hailed over a loudspeaker to come down to the runway prior to boarding at Heathrow. There I had to

identify my bag and remove a stock of batteries packed for a long shoot in the Arctic. Since this fiasco, I now stash batteries in my photo vest, which I wear on the plane.

However if you are ever flying within India, you can come horribly unstuck because there batteries cannot be carried in pockets or in hand baggage but must be placed in the checked baggage! On my first trip to India, an overzealous bureaucrat gleefully accused me of attempting to smuggle in batteries and promptly not only confiscated my entire stock of new packs, but also stripped my flashlight and alarm clock. Someone must be working a black market in batteries out there!

Some years later, when I led a photographic tour to India, I warned the entire group, but no one heeded my advice. As we were going to a remote area where we were very unlikely to see—let alone buy—another battery, I had to plead with the officials for me to gather all the batteries into a plastic sack so I could pack them into my checked baggage. By this time, my bags were already on the runway, so I had to be escorted out of the terminal by an armed guard!

The point is, be prepared so that you don't arrive at your destination without any means of powering your cameras and flash! To find out the regulations that apply to the country of your ultimate destination, call the press office of the airline you plan to use.

CAMERA BAG
TIPS AND HINTS

Carrying Gear

A robust camera bag is essential for protecting expensive equipment and ensuring that everything arrives intact, especially when traveling across rough terrain. Over the years, I have accumulated more than a score of different camera bags, all of which have some plus points. My choice depends on the length of the trip and how much gear I need to take, whether I am working from a vehicle, wading through water, or trekking up a mountain.

Before buying a new gadget bag, check the following:

❏ Is it comfortable to wear over rough ground?

❏ Is it a regulation size for airplane carry-on?

❏ Can its inner compartments be rearranged to accommodate different equipment combinations?

❏ Does its layout provide speedy access to gear?

For anyone who is serious about trekking, a padded photo rucksack is a must, so that both hands are free for climbing or pushing branches away from the face. Ensure that your backpack has:

❏ A thick waist strap with a quick-release buckle

❏ Thick, padded shoulder straps that are adjustable in length

❏ A sternum strap to prevent the shoulder straps from slipping

❏ A separate front pocket for stowing wet clothing

❏ Optional side pockets for extra lenses and a water bottle

◀▥ **A padded photo backpack is the safest way to carry gear over uneven terrain. Photo by Giles Angel.**

❏ Lash tabs for a tripod and umbrella

❏ An all-weather cover for protection from dust, sand, rain, or snow

Access to many large photo packs is gained via a single zippered cover that can be opened only by laying the pack on the ground. This may seem fine in the store, but not in mud or snow. Also, when such a pack is opened in rain or snow, all the gear is liable to get wet. The OutPack line of photo packs is designed to allow you to have speedy access to the particular lens or body you need without exposing all your equipment to the elements.

The Stronghold line of bags produced by Lastolite® are fitted with rigid, yet adjustable, Procam® frames (covered with inert foam) for extra strength.

An unpadded waistpack—available from any outdoor supplier—is invaluable for having film ready in any location. When working in water, I use a padded waistpack as a wading bag to provide easy access to film, lenses, filters, and flash without having to trek in and out of the water to get to my main pack.

While the largest photo packs can take a fast 500mm lens, much better protection will be gained by carrying it in a separate bag when traveling or working from a vehicle. Domke® produces three long-lens bags—the J300 holds a 300mm f/2.8 lens, the J400 takes a 400mm f/2.8 lens, and the J600 will comfortably hold a 600mm f/4 lens. Check Tip 82 for a description of the capacious OutPack® ScopePACK™.

Hang Around with a Carabiner

Carabiners are the D-shaped metal rings used by climbers to fasten ropes. They can be opened single-handed and have a spring catch that closes automatically upon release.

Available in small sizes from good outdoor and mountaineering suppliers such as REI, carabiners are invaluable for hanging a host of items from a waist belt or camera pack. I use one for

hanging small collapsible reflectors or diffusers so they are always at the ready. If your water bottle doesn't come complete with its own waistband, you can use a carabiner to attach it to your pack or belt via a cord loop secured around its neck.

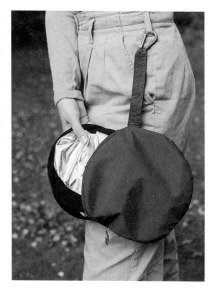

A carabiner provides a handy way to hang light-weight items, such as this reflector, from the waist.

10 Quiet, Please!

Hook-and-loop fastenings, such as Velcro®, which are used to secure clothing, photo vests, and camera bags, make for speedy opening and closing, but the ripping sound can frighten timid animals. While this won't matter when taking plants or landscapes, it could cost you a wildlife shot. When you have spent an age creeping up to your quarry, you don't want to disturb it by suddenly ripping open a pocket for a fresh roll of film. The noise may simply induce an animal to stop feeding and look up (which can be an advantage), but it may just as easily cause an animal to run away. So, whenever possible, avoid buying clothing or any items with Velcro-type fastenings that will require opening or closing when out in the field. Although the covers of Tri-Pads (see Tip 67) are secured with Velcro strips, they can be fitted to or removed from a tripod before you venture outdoors.

11 Prevent a Disappearing Act

How many times have you dropped a small black cable release into long grass and spent hours searching for it? I got to the stage of buying my releases six at a time so that I always had a few spares. Then I recalled how noxious-tasting animals make themselves as conspicuous as possible, thereby warning any would-be predators to leave them well alone. Their natural warning colors are typically yellow and black; red and black; yellow, red, and black; and black and white, so I decided to add stripes of yellow insulating tape to my black releases to make them easy to locate when dropped in grass or leaf litter.

Allen wrenches—so essential for tightening up quick-release plates—are even easier to lose, since they are smaller and disappear completely into leaf litter. Mine now sport white stripes (bands of self-adhesive labels) alternating with the black metal. They are carried inside an OutPack Minipack with the rest of my fix-it kit (see Tip 4).

Adding stripes to cable releases and Allen wrenches makes them easier to locate if they happen to drop into leaf litter or grass.

A Cable Release Splint

Aside from the times you're taking hand-held action shots or using a monopod or a beanbag, a cable release is vital for ensuring crisp images at longer exposures. A plunger-style release may be a small and inexpensive item, yet it can cause a great deal of aggravation. If you haven't lost it in the field (see Tip 11 to reduce the odds), then sooner or later it develops an ominous bend at the junction where the metal collar meets the outer sleeve near the base.

I cannot recall how the ratio of releases lost in the field to those thrown away with a kink in them now stands, but I decided there had to be some way of counteracting the gremlin that damages the release between trips. So I hit on making a splint. I use a couple of wooden cocktail sticks or toothpicks to strengthen the release before it is bound up with colored waterproof tape. Since the junction between the end of the tape and sleeve is more pliable than the junction between the metal collar and the sleeve, it is much less likely to develop a permanent kink.

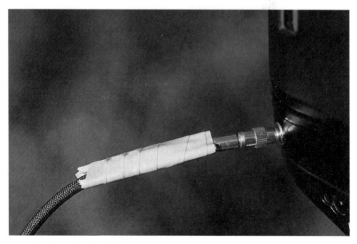

A pair of cocktail sticks bound with waterproof tape can be used to make a splint, which prevents damage to your cable release.

13 Identify Exposed Film

When the action is fast and furious, the last thing you want to do is spend time numbering exposed rolls of film. Yet after a long shoot, identifying specific rolls to pull out for speedy processing can mean the difference between clinching or losing a quick sale. So, I place any film with shots depicting unique behavior or featuring dramatic lighting in a separate pocket so it can be specifically identified at the end of the day. And even if I don't number each roll as I shoot it, I make sure that all the exposed rolls are numbered at least when the action is over, and I record these numbers in my field notebook (see Tip 15). In this way, I can have all the films taken of a pride of lions, for example, processed (in different batches) within one working day.

When it comes to labeling film rolls, any pen or pencil can be used to write directly on medium-format rolls, whereas an

After a day's shoot, identify rolls by numbering them and marking the ones that were "pushed."

alcohol-based pen is essential to record a permanent mark on 35mm cassettes. However, I prefer to use self-adhesive numbered labels because then I don't have to remember the number I gave the last roll! I also have small stickers printed "DOUBLE RATED," which denote films that have been pushed by one stop, but writing on plain white self-adhesive labels is a more flexible way of recording different degrees of pushing.

Upon my return I separate the rolls from each day's shoot into batches for processing over the course of several days. Having suffered several processing disasters, I have learned to spread the risk. I then transfer the film number to the outside of each processing envelope beside my address. My processing lab transfers the film number onto the protective sleeving of the unmounted film after it is processed, while the mounted films are identified by the number on my address panel.

I find this discipline has a three-fold advantage. Not only does it help to identify the subjects taken on a daily basis and keep a check on my cumulative film consumption, but it also ensures that I no longer risk losing all the film from one day's shoot through processing mishaps.

School of Hard Knocks

All my color work has been on transparency (slide) film, but ever since I tripped and banged my 80-200mm AF Nikon lens on the ground in Yellowstone National Park, I always carry a roll of color print film. I use this to test equipment that has suffered a blow to see that it is still functioning correctly. This is because there are more one-hour mini-labs that cater to the print market than there are labs that process transparency film.

I was lucky in Yellowstone because I could buy a 20-exposure roll and get it processed at the same place. I went out and shot buildings and buses—anything that allowed me to check the focus was OK across the entire frame and that none of the internal lens elements had worked loose.

Fortunately there was no problem, but I didn't want to risk a two-week wilderness shoot with a faulty favorite lens. The whole episode—buying the film, exposing it, and seeing the processed prints—took just 80 minutes.

15 Use a Field Notebook

Maybe my scientific training was responsible for instilling a dogged determination never to venture outdoors without a small hard-backed field notebook. But I do not use it to record my exposures! (I frequently have debates with editors when I refuse to put exposure details in my captions, since I argue it is unlikely anyone else will frame the identical shot with the same lighting, lens, and film combination.) I do, however, use it to jot down local or scientific names of plants or animals, aspects of animal behavior, the angle of the sun at a precise time of day (with notes on how problem areas could be overcome at a later date), or I may simply make notes about the changing moods of the weather while I am waiting for an animal to appear. Also, I may record the lens focal length or if a filter was used so the information is there should I need to write a technical caption.

At the time we think we can remember all we experience, but it is all too easy to forget small snippets that can usefully embellish captions or text. I find the discipline of putting pen to paper invariably means I remember most, if not all, of the photographic details. Although I may not re-read every word I have written, I find it helps to increase my awareness at the time as well as serving as a very useful *aide memoire* at a later date.

One of my China notebooks enables me to relive a unique day I spent in a botanical garden with an elderly botanist. Neither of us could speak the other's tongue, but we managed to converse all day long in botanical Latin! I still treasure the names he wrote in my notebook, which helped me to accurately caption pictures after I returned home.

Ballpoint pens are not recommended, since they refuse to

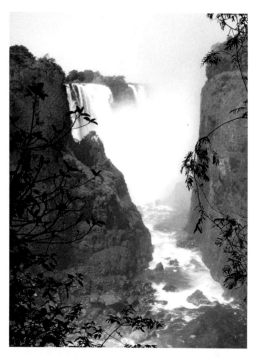

Notes that I made on location at Victoria Falls, Zimbabwe provide invaluable information for later use in captions: "Riverine forest frames Falls (known locally as Mosi-oa-Touya) from Zimbabwe, Cataract Island on left."

write when it is cold and tend to leak in hot climates. I normally use either a mechanical pencil or a roller-ball pen, but in humid tropical rain forests or in rain I use a waterproof pencil and note-book. Better still is the Fisher Space Pen®, selected for use on all manned Apollo space flights because it writes in temperatures between –50° F and +400° F (–45.5° C and +204° C), as well as in a gravity-free void, underwater, and even when held upside down!

An alternative to pen and paper is to use a pocket tape record-er, preferably one that is voice-activated so you don't have to keep switching it on and off. Even more compact are the Olym-pus Note Corders™, which weigh a mere 1.2 oz. (35 g) each and store short messages directly on a computer chip.

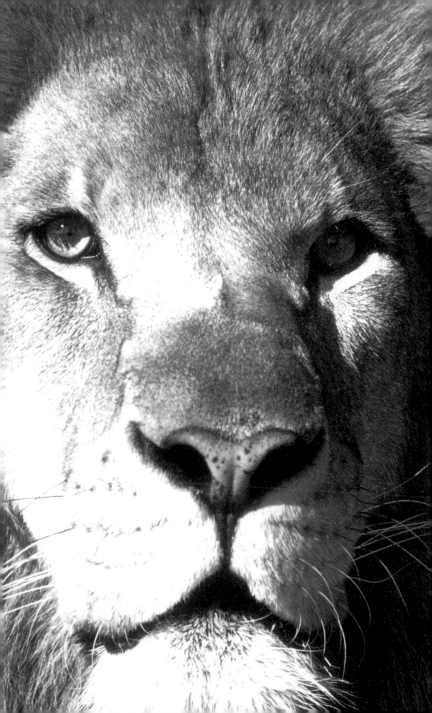

CAMERA SUPPORT TIPS AND HINTS

16

Steady as She Goes

Have you ever wondered how slow you could set the shutter speed without running the risk of getting a blurred image in a hand-held shot? The rule of thumb is to set the shutter speed closest to the reciprocal of the focal length of the lens in use (for example, 1/250 second with a 200mm lens or 1/60 with a 50mm lens). By following this guideline, the chance of camera shake is minimized.

However, if you are shooting in poor light without a tripod, slower speeds can be utilized by bracing your body against a solid object such as a tree, wall, or vehicle. If you are stuck with a treeless, flat wilderness, then you can use either your body or the ground itself to help steady the camera. Sit on the ground and use each knee to support an elbow, or alternatively, kneel one-legged and use the upright knee to support both elbows. Even greater stability can be achieved by lying prone like a marksman and resting your elbows on the ground. A low-level belly-crawling approach—providing you are downwind—will also increase your chances of getting closer to a wary mammal.

◄▥▥ **A rigid tripod was essential for supporting a 500mm lens for this frame-filling portrait of a lion. (C)**

17

Bring a Beanbag

Whether you're shooting on safari in Africa or taking pictures of polar bears from a tundra buggy, if you are using long lenses from a vehicle, a beanbag is far and away the most effective camera support. Ready-made Ben-V beanbags come in three sizes (2 lb., 4 lb., 6 lb.) with a zip fastener for speedy filling. They also have a carrying handle at each end, complete with a quick-release buckle. The handles on the Ben-V beanbags not only allow several bags to be linked together but also enable them to be attached to the vehicle to prevent them from falling overboard should the driver move off without warning. I once saw a polar bear make mincemeat of a beanbag that went overboard at Churchill in Canada!

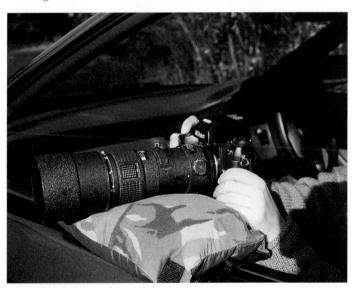

Use a beanbag to support your camera and lens on the window frame of a vehicle.

To save weight when you are flying, carry your beanbags empty, and when you reach your destination, fill them with dried beans, peas, rice (always available in even the most remote locations), or polypropylene granules. In a pinch, you can make your own beanbag from a pillowcase (use a subdued color). Fill the case only half full so it can be tied by knotting one end. Don't overstuff the bags; leave enough space for making a hollow in which to nestle a long lens.

Regardless of size, the beanbag is draped over the vehicle's window frame and a concave depression made in the center to support the lens. This simple support enables shutter speeds as slow as 1/4 or even 1/2 second to be used with confidence, which cannot be said when the camera or lens is supported at a single point on a tripod and a wind is blowing. Also, fine adjustments to the camera angle can be made very speedily when a beanbag is used.

Beanbags can be useful in other situations as well. When you are shooting with a tripod, a heavy beanbag with a strap can be used to increase the stability of the tripod by hanging it from the center column, around the tripod's "shoulder," to add ballast beneath the camera. Also, if you are stuck with a camera without the facility of a mirror lock, a beanbag placed on top of a camera with a long lens can dampen the vibration caused by the mirror flipping up.

18

Use a Window Mount

When using a vehicle as a blind and it has a window that rolls up and down, I like to use a window mount to support a long lens so I can shoot at slow shutter speeds. I have tried several types, and the most robust window mount I have found is produced by Kirk Enterprises. It's a heavy-duty model capable of handling lenses up to 800mm. Although a beanbag offers adequate support in certain situations (see Tip 17), a window mount with a ballhead

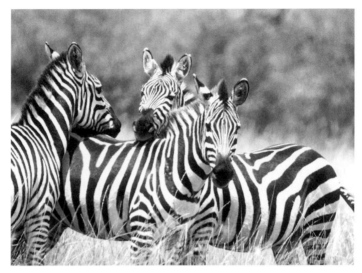

A vehicle makes a great mobile blind when on safari. I used a window mount to steady my long lens when taking this Burchell's zebra trio in Kenya's Masai Mara Reserve. The mount can also be used on the ground, as shown on page 37.

(for mounting the lens) is more convenient to use when changing rapidly from a horizontal to a vertical format.

Made of black anodized aluminum, the Kirk model is secured by rolling the window down until the top 2 inches (5 cm) stands proud from the base of the frame. The mount is then clamped onto the glass, and the whole is secured against the inside of the door by a hinged bracket with rubber-covered feet. When I am driving a vehicle on my own I tend to secure the window mount on the passenger's side and have the camera at the ready on the seat next to me.

This mount can also be used rested on any flat surface, be it the hood or roof of a car, or the ground, where it can function as a low-level camera support (see Tip 19).

How Low Can You Go?

Shooting with the camera down at ground level is common in nature photography (see Tip 33), so it's important that you have an appropriate low-level support.

Many tripods are designed for taking a camera down to a worm's-eye view. Look for those whose center column can be replaced with a shorter one, positioned virtually flush with the ground (such as a Benbo), or dispensed with altogether. Some tripods have a reversible center column or a reversible head, and those will work too.

But even if your tripod has an adjustable center column, its legs can still present a problem for shooting at a low angle. If the sun is shining, they may cast shadows over the subject, and even if the weather is overcast, they can be an obstacle to maneuvering or focusing the camera.

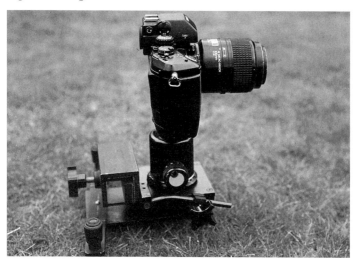

When placed on the ground, the Kirk window mount can be used as a low-level support.

So, to solve this problem if the ground is soft but firm, the best lightweight, inexpensive low-level support is a ground spike. This accessory can be made by welding a screw (for mounting a ballhead) and horizontal arms to a sturdy metal tent peg (available from a camping store). The camera is attached to the ballhead, which is screwed onto the spike. The arms not only aid in pushing the stake into the ground, but also stop it from sinking below the surface. If the ground is hard and flat, a low pod can be made from a piece of wood with a ballhead attached.

Commercially available products include a ready-made ground spike by Cullmann®, while Kirk Enterprises offers the Low Pod, which comes complete with three rubber-covered feet and accepts any tripod head.

No matter what low-level support you use, if your camera features a detachable pentaprism, substitute it with a waist-level or right-angle viewfinder for easier composing and focusing without having to lie completely prone to get your eye up to the viewfinder.

20

Use Lens Collar Supports

Without proper support, the weight of a long lens can cause permanent damage to the lens mount, affecting the angle of projection of the image on the film plane and making unsharp images. Fortunately, most fast long lenses come with their own tripod collar so that the heavy lens, rather than the camera, can be mounted on a tripod. By slackening the locking screw on the collar, the lens (and camera) can be rotated to allow a rapid change from horizontal to vertical format and back again.

In the past, many of us have suffered a loss of sharpness in our pictures due to mirror vibration with some heavier lenses that were produced without a tripod mount, notably the Nikkor 80-200mm f/2.8 zoom and the larger Hasselblad lenses. Fortunately, Kirk Enterprises has produced their EZ-360 Quick Release Mount,

which not only allows rotation of the camera through a full 360°
on its axis but also quick coupling to a tripod. This permits a
speedy change from one format to another without having to
touch the tripod mount. As I write, Nikon has just announced the
production of an 80-200mm f/2.8D ED lens complete with its
own tripod mount.

Kirk Enterprises also produces a collar complete with a quick-
release mount for supporting the Hasselblad 350mm f/5.6 CF
lens, although in this case, there is no need to rotate the lens
when composing pictures with the square 6 x 6 cm format.

21

Pollution Protection

Not until I was faced with documenting the horrendous oil spill
from the *Sea Empress* in southwest Wales in the spring of 1996
did I consider the best way to protect my equipment. The weather
was overcast, and I wanted to take macro shots of dead and dying
limpets, so I had no option but to take a tripod onto a beach cov-
ered with several inches of "mousse" (a viscous concoction of oil,
water, and emulsifier, which emitted a nauseating smell of crude
oil). Before I set out, I had the foresight to load a box of tough
plastic bags into my car, together with some thick rubber bands.
Each tripod leg was then wrapped with a plastic bag secured with
several rubber bands. Because there wasn't one square inch of
unpolluted shore, all my cameras and lenses had to be stashed in
either a wading bag (see Tip 8) or photo vest. A disposable overall
(kindly donated by the people working on the clean-up opera-
tion) covered all my clothes and was discarded immediately after
the shoot, but my rubber boots still carry splatters of oil residue.

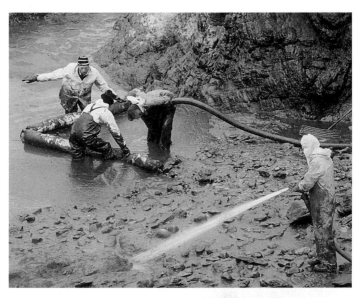

The 1996 *Sea Empress* oil spill in Wales posed an enormous threat to the lives of sea birds and marine life. To document the devastating effects of this disaster, I had to protect myself and my equipment from the nauseating and omnipresent chocolate-colored "mousse" (a mix of oil, emulsifier, and sea water) that washed ashore on many beaches.

22

Wet Feet, No Bother

There is no question that when long lenses are used, shooting with a tripod ensures a much higher proportion of sharply defined pictures than shooting hand-held. But some situations, such as when working in water or fine estuarine mud, are not conducive to using many types of tripods without some added protection to the legs. For example, tripods that have non-anodized lower leg sections will corrode after immersion in sea water. However the unique design of the British-made Benbo, with the

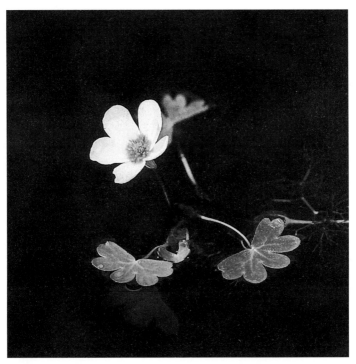

Getting this simple study of water crowfoot required wading into the edge of a pond and immersing a Benbo tripod into a foot of water.

widest leg tubes at the base and finished with a black waterproof coating, allows for safe immersion in water. The standard Benbo 1 tripod can be used up to a depth of 21 inches (53 cm) of calm water (be sure to erect the tripod and test that the feet are secure on a rocky shore or the bottom of a lake or river bed *before* attaching the camera).

If you don't have a Benbo, thick plastic bags firmly secured with rubber bands can be used as a temporary waterproof measure, although care must be taken not to rupture the bottom of the bags on jagged rocks. In any case, don't forget your waders, otherwise *your* feet will get wet!

41

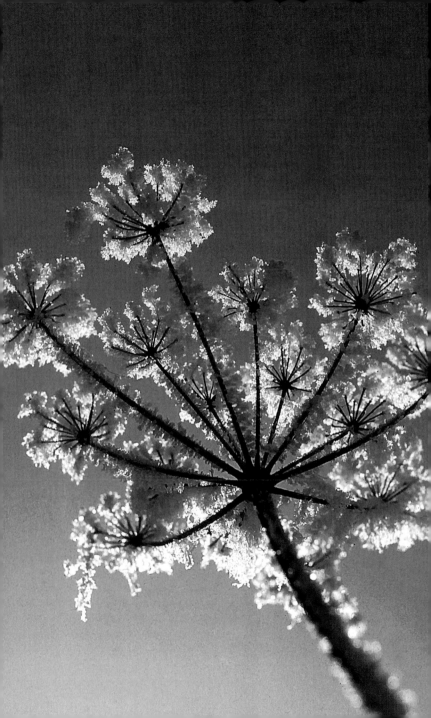

TIPS AND HINTS
FOR METERING

| 23 | **Meters Can't Think** |

Modern cameras may be able to do a lot of things, but their meters cannot think. They are designed to expose for medium tones, so when you don't have an incident light meter and have to rely on the reflected in-camera reading, you need to seek medium tones. Green grass (*not* bleached grass of the African savanna during the dry season) is a good medium tone to use for manually metering a scene with dark-skinned animals or a landscape with a range of tones.

Everyone who spends any time out of doors is aware of the plethora of greens that occur in the natural world. Not only do they range from pale to dark, but also from matte to glossy. Beware of metering yellow-green or dark green leaves, as this results in underexposing or overexposing (respectively) an average tone. Highly glossy leaves—also known as "lively" leaves by landscape designers—reflect a lot of light and hence also give an erroneous reading.

Lacking an incident light meter, you can use a Kodak gray card as a portable 18% medium tone for taking a reflected reading with your camera's TTL meter. Using the camera's manual mode, meter the light reflected from the card placed in front of or beside the subject. Refer to the instructions supplied with the gray card for best results.

◀ **I used in-camera matrix metering to take this frosty close-up of a hogweed seed head: The gray frost (in shadow) and the blue sky were good average tones, while the areas taken up by white frost (in sun) and black stems were roughly equal.**

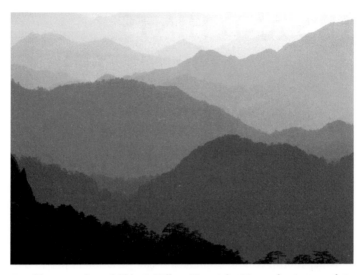

For this succession of China's Yellow Mountain (Huangshan) ranges late in the day, I spot metered off the medium-gray range in the lower right corner of the frame.

A Kodak gray card is a safe way to meter a shrub with highly reflective, light-toned leaves.

If you persistently get under- or overexposed transparencies, your camera meter probably needs to be checked. It may be necessary to calibrate it by adjusting the nominal film speed.

24 | Backlighting Basics

Photographing objects against the light will add drama to the picture, bathing solid structures (such as spiny cacti, flowering grasses, or a hedgehog) with rim light and giving translucent flower petals or red leaves a radiant glow. The downside of working against the light is that tiny subjects, such as midges (minuscule flies) dancing against a dark background, are reminiscent of a snowstorm! The same aura that gives larger objects definition overpowers the minute size of the midges, and only the glow of light is recorded!

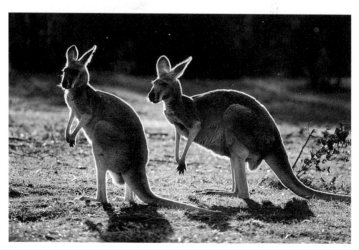

To meter this rimlit shot of two red kangaroos in Australia, I spot metered off on an area of average-toned green grass in sunlight. The white spots are backlit flies.

When shooting into the light, whether out in the open or in a forest, take care to use a lens hood (or lacking that, your hand) to prevent the sun from shining directly into the lens and causing flare. When using a filter, the threat of flare is further exacerbated because the filter glass is even more exposed than the front lens element.

If your subject is stationary, you can take an incident reading of the light falling on it using a hand-held meter. However, back-lighting can be tricky. The animal you are taking could move unexpectedly or the sunbeam could become obscured behind a branch, a trunk, or a cloud. If this is the case, you need to be able to use the camera's TTL meter quickly and accurately, otherwise the magical effect of the picture could be lost.

I have adopted two methods for using TTL metering in manual mode. For taking translucent green or red leaves as well as large-petalled flowers, I manually spot meter the light shining through the leaf or petal, remembering to compensate for yellow or pastel-colored flowers by opening up on the reading. For delicate plants such as grasses or rimlit solid subjects, I turn around 180° from the subject and manually meter the light falling on an average-toned subject (green grass or leaves). If there is no natural average tone, I either meter off a pale tone and open up a stop or meter off a Kodak gray card.

25 | Use Your Camera as an Incident Light Meter

When faced with a white wilderness without any medium tones from which to take a TTL reflected light reading by the camera (see Tip 23), and lacking a hand-held incident light meter, you can easily convert your TTL camera into an incident light meter. To do this, you need to fix a diffusion screen over the front of the lens.

Quite by chance, I found that a white cap from a small aerosol can fits perfectly onto a 105mm Micro-Nikkor lens. For larger-diameter lenses, a pint-sized plain white plastic deli container or a sheet of translucent white plastic will do.

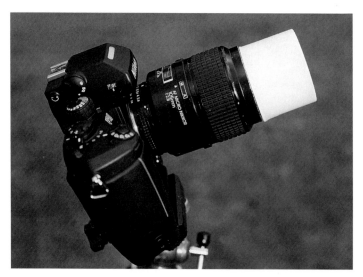

A white aerosol can cap placed over the lens can be used as a diffuser, allowing your camera's meter to take TTL incident light readings.

To customize a sheet of white plastic to fit the exact diameter of your lens, first draw the circumference of the lens on the plastic. Then cut out a circle approximately two inches (5 cm) wider than the circle you have drawn. Make repeated cuts toward the center of the circle only as far as the circle you have drawn. The plastic flaps are then overlapped and folded down onto the lens barrel to make a lens collar. Finally, use some tape to secure it to the lens.

Before relying on this device for metering very bright or very dark subjects, it is essential that you calibrate it first. This can be done by borrowing an incident light meter or by taking a TTL reading of a known average tone (such as a Kodak gray card). Either way, it is most important that the calibration be done during a period when the lighting remains constant. Coincidentally, when I calibrated both the aerosol cap and the sheet-plastic diffuser, I found I needed to add a layer of white photocopying paper inside each one in order to come up with an accurate reading.

Don't forget, the correct orientation for using an incident light meter is by measuring the light *falling onto* the subject, rather than *reflected off of* it. You will therefore need to direct the camera away from the subject 180°.

26 Metering Bright Subjects

Whether you are photographing white sand dunes, a snow-covered landscape, or a mass of white flowers, if the camera's TTL reflected reading is used, the pristine scene will appear a dirty gray, i.e., *under*exposed. In-camera meters expose for a medium tone, and that is what you will get unless you compensate for the subject.

Color slide film has much less latitude than print film and is capable of recording only about 2 stops on either side of the camera's midtone reading. So when faced with a white subject, how can you ensure you will record the right tone? One way is to take an incident reading of the light falling on the snow (either by using a hand-held meter with an incident dome in place or by putting an incident cover over the camera lens [see Tip 25]).

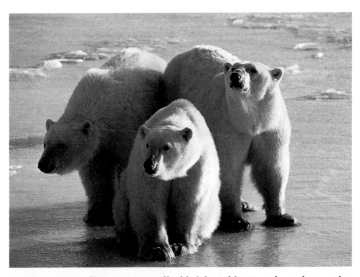

Using a TTL reading to meter off of bright subjects such as these polar bears on snow-covered ice will result in an underexposed picture. I spot metered off a shadow area on one of the bears' legs.

Another method for static and accessible subjects such as white flowers or a frost-encrusted plant is to place a Kodak 18% gray card nearby and meter off it using the camera's manual mode. When photographing polar bears, however, this simply isn't practical! So, once again using manual mode, I either spot meter off a part of the bear in shadow and go with that reading, or I take a reading off the bear in the sun and adjust it. For light shadow tones, I open up 1 to 1-1/3 stops, and for textured rimlit white subjects I open up 1-1/2 stops.

Remember to think about tones and what proportion of the frame the high key (pale) and low key (dark) areas occupy. Take, for example, black, burnt tree trunks against snow (as can be seen in Yellowstone in winter). If the area occupied by the black trunks is equal to the area occupied by white snow, each cancels the other out, and a matrix in-camera reading can be used without any adjustment.

I haven't mentioned using the exposure compensation dial for adjusting the camera's reading of tricky subjects for the simple reason that from bitter experience, I have found it all too easy to forget to reset the dial back to zero!

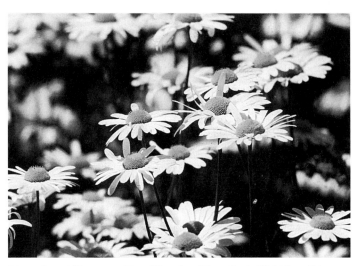

I knew I would have a problem if I metered the reflected light from this mass of white flowered ox-eye daisies, so after composing the picture, I swung the camera around and manually spot metered a patch of green grass.

27 | Metering Dark Subjects

This tip should be read in conjunction with the previous one, since once again, it is all about the camera's TTL meter attempting to produce a medium tone. Very little light is reflected off of dark fur or feathers, black rocks, somber conifers, or scenes with large shadow areas, so the camera wants to open up. The end result when sticking with the camera's TTL reflected reading will be

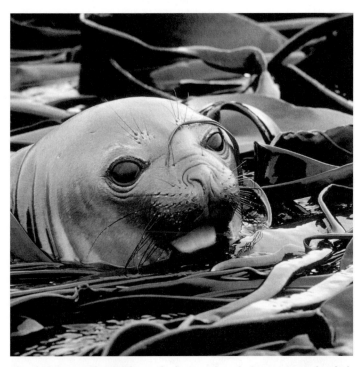

The dark tones of a southern elephant seal surfacing amongst the dark kelp reflect little light, so a straight TTL reading will overexpose the image. One solution is to use an incident light meter for a more accurate exposure.

pale, *over*exposed pictures. Therefore, contrary to one's initial instinct you need to *stop down* on the camera's reading. The question is, how much?

First of all, I look around to check if there is a midtone object (mid-gray rocks, green grass, or leaves) adjacent to the dark subject. If so, I focus on the subject and manually meter (not changing the focus) off the rocks, grass, or leaves and go with this exposure. Having done this, it is a useful exercise to compare the reflected reading off the dark subject. With experience, it should then be possible to predict by how much the camera needs to be stopped down.

But when faced without a suitable rock or leaf, no means of metering the incident light, and when it's impractical to meter from a gray card, then you need to look at the tonal range of the image area. Seabirds such as murres or guillemots are adorned with roughly equal portions of black and white feathers. Like the trees-and-snow example cited in Tip 26, the evenly distributed white and dark areas will cancel each other out, and so the matrix reading can be used without any correction. But if more than half the area within the frame is dark, you will need to stop down 1/2 to 2/3 stop, and if the whole area is dark, you may need to stop down 2 stops. In these situations it is worth bracketing until you are confident of the way your meter "reads" and your ability to appraise a subject in terms of its tones and reflectance.

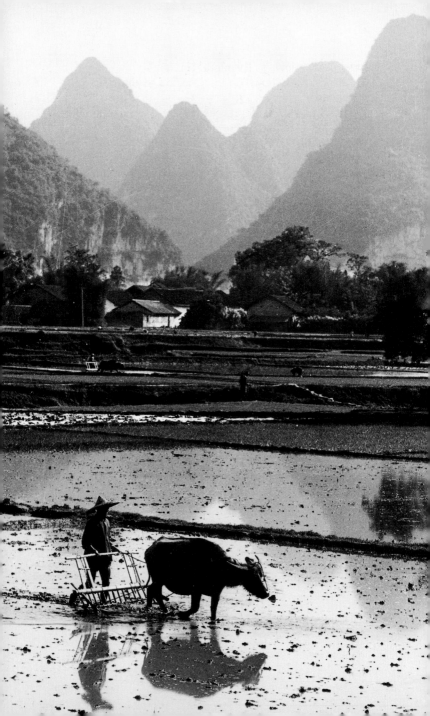

TIPS AND HINTS
FOR COMPOSITION

28 Brighten Your Outlook

Unless you are totally won over by autofocus (and it is certainly not the answer to maximizing depth of field with close-ups) a clear, bright viewfinder is essential to ensure precise manual focusing as well as aiding composition. For many years I have used Beattie® Intenscreens™ in my Hasselblad viewfinders. They increase the light passing through the viewfinder by as much as 3 stops (on medium format) or 2 stops (35mm format), which especially aids focusing in low light or when long lenses are used. As a result of this increased brightness, the iris of the eye used for focusing automatically contracts (stops down), thereby increasing visual acuity. All screen sizes are available plain or gridded, and some have a split-image rangefinder.

Be aware, however, that when a screen that reflects more light than normal is fitted to a camera with TTL metering, it is likely to affect the meter reading and hence will produce underexposed images. Therefore, after fitting a Beattie Intenscreen to your camera, check the TTL meter reading immediately against that of an incident light meter. If necessary, calibrate the in-camera reading by adjusting either the exposure compensation dial or the film speed setting. Some top-of-the-line cameras have a compensation mechanism inside the viewfinder.

◀ **Even though this rural Chinese scene was a grab shot, it was still composed to include foreground interest (a farmer and water buffalo with their reflections in a flooded rice field) as well as distinct middle and distant elements.**

29 Go the (Hyperfocal) Distance

Autofocus (AF) is a great asset in certain situations. However I am convinced that it is responsible for spoiling many landscape and close-up shots simply by creating an inappropriate or too shallow depth of field. Knowing how to control depth of field by setting an appropriate aperture and focusing distance is crucial to perfecting your composition.

Depth of field is the zone of apparent sharpness on each side of the plane of focus, and it is determined by the combination of image size and aperture. The greater the magnification on the film, the shallower the depth of field. If the same subject is taken with a 28mm and a 50mm lens from the same camera position and using the same aperture, the depth of field will be greater with the wide-angle lens (the image size is smaller). It is interesting to note, however, that if the image size and aperture used

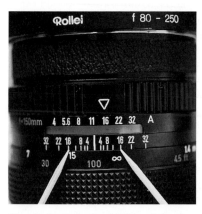

Use the lens' depth-of-field and distance scales to determine the depth of field you will get at any aperture. Here, a 150mm lens on a medium-format camera gives a depth of field extending from 15 meters to infinity if set at an aperture of f/16.

with different focal length lenses are identical (with a standard 50mm lens this means moving farther away from the subject), then the depth of field will also be identical, although the perspective will, of course, change.

If a lens is used wide open, the picture will appear sharp only in the focused plane, and stopping the lens down to a smaller aperture will increase the depth of field on *both sides* of the plane of focus. However, contrary to popular belief, maximizing depth of field does not necessarily

mean setting the smallest aperture, indeed when this is done, definition is actually reduced.

Except in close-ups (see Tip 93), depth of field extends approximately 2/3 behind the plane of focus and 1/3 in front of it, so if the lens is focused on infinity and stopped down to a small aperture, some of the potential depth of field in front of the plane of focus is not utilized. Therefore, when taking landscapes with a camera (or a lens) without a tilt facility, maximize depth of field by using the lens' hyperfocal distance—that is, the focusing distance that gives the greatest depth of field at a given aperture. Or, said another way, it is the closest point at which you can focus so the depth of field includes infinity. As a rule, everything from half the hyperfocal distance to infinity will fall within the depth of field. Hyperfocal distance varies with focal length and aperture. Here's how to use it:

First select a lens and compose the picture. Decide on the nearest object you want to appear sharp. Manually focus the camera on that object and read the distance on the lens barrel. Let's assume this is 10 feet (3 m) away. Now determine the hyperfocal distance by doubling that distance. (It is always twice as far as the nearest object in focus.) Refocus the lens at the hyperfocal distance, then look at the depth-of-field scale printed on the lens barrel. In this example, the aperture number that aligns with both 10 and infinity (each aperture appears twice on the depth-of-field scale) is the aperture needed to get everything in focus within that range. (For example, with a Hasselblad 80mm lens this is virtually always f/5.6, but to play it safe I would go for one additional stop [f/8].) Now set the aperture and its corresponding shutter speed for the desired exposure and shoot.

Sometimes you won't require such an expansive depth of field as the hyperfocal distance gives you. In that case, you can set a larger aperture. To determine the appropriate aperture for the depth of field you want, focus on the nearest object and then on the farthest one, looking at the distance scale to determine the two extremes. Now rotate the focusing ring until the near and far distances align with a matching set of apertures on the depth-of-field scale. By using this technique and setting the aperture that's indicated, the camera and lens are set to maximize the depth of field that will safely span the desired distance range.

Not all lenses have a depth-of-field scale. Some AF lenses

have dispensed with them altogether, and others have a scale located within a window, making it very difficult to read. If this is the case with your lens, use a hyperfocal distance chart (found in some books) or the information provided with the lens. Some cameras even have a depth-of-field mode, which makes these calculations for you automatically!

A better understanding of how the aperture affects depth of field can be gained by using the depth-of-field preview button (if your camera has one). Look through the camera and stop down the lens all the way. While pressing the depth-of-field preview button, open up and close down the aperture *slowly*, letting your pupil adjust to each setting. With a little practice, you will be able to discern the subtle changes in the depth of field at different apertures.

Use a Zoom

No doubt the debate surrounding zoom lenses will rage on forever. While they tend to be heavier and less compact than prime lenses, don't forget, one zoom may replace two or even three prime lenses. One negative aspect of zooms is that they tend to be slower, and therefore do not aid in separating the subject from the background quite so well as fast prime lenses. The big bonus of zooms however, is that precious time is saved in not having to repeatedly exchange lenses; they also allow for precise composition and cropping in-camera.

Different markets dictate different formats. For example, magazine covers are invariably vertical, and if the picture is bled off all-round, then a vertical shot is required. Calendars, on the other hand, traditionally use horizontal pictures, although the choice of format will naturally depend on the shape and size of the calendar. So if time permits, it is sensible to shoot both horizontal and vertical shots of the same subject. Since this invariably means changing the focal length to get a harmonious composition, this can be done most speedily with a zoom.

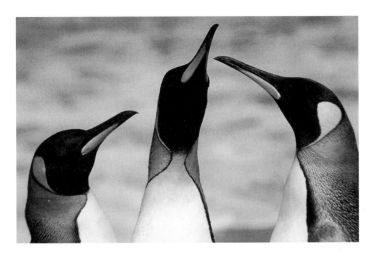

An 80-200mm zoom lens allowed me to precisely frame the heads of this trio of king penguins in South Georgia, Antarctica.

In addition to a complete range of prime lenses, I have four zooms that provide virtually continuous coverage from 20 to 400mm. They are the 20-35mm f/2.8 AF Nikkor; the 35-70 f/2.8 AF Nikkor; the 80-200mm f/2.8 AF Nikkor, and the much sought-after 200-400mm f/4 Nikkor. Even though the 200-400mm weighs in at nearly 10 lb. (4535 g) (with lens hood and quick-release plate) and is a manual lens, it is my favorite because the range is ideal for showing larger mammals in their habitat and for taking groups of mammals.

Keep It on the Level

When photographing buildings with distinct horizontal and vertical lines, it is easy to check whether the camera is level, but out in the wilderness on uneven ground and without a level horizon, it is not nearly so straightforward. A hastily composed picture may look OK in the viewfinder, but on close examination of the transparency or print, the composition jars the eye because the camera wasn't level.

A bubble level seated in the camera's flash shoe ensures that the camera is kept level.

Fortunately, a whole host of devices incorporating bubble levels for photographers now exist. Some tripod heads come complete with a level and so can be used with any make of camera. Hasselblad produces a small level that slides onto the side of its camera bodies, while the Hasselblad FlexBody™ has a level on top of the shift control knob.

Several universal bubble levels are available. Some slip into the flash shoe, while others screw into the cable release thread of some shutter release buttons. It is worth trying to get one with levels for both horizontal and vertical axes. But by far the cheapest way to level a camera is to purchase a bubble level for a few cents from a hardware store and fix it in place using a thin layer of adhesive putty or double-sided tape.

Scenic Overlook

32

Flat landscapes—notably lakes—will look nothing short of disappointing when photographed from their own level. Unless an ultra wide-angle lens is used to gain foreground interest, such subjects will appear as a small strip of land (and/or water) with a large expanse of sky. The solution is to find ways and means of gaining height. Sometimes all that is needed is a wall, a small hill, or a bridge (to look down onto a river). Many a time I have blessed the custom-made boarded roof rack on top of my 4WD sport utility vehicle—providing I can maneuver it into the right position.

When at sea, a high-level deck offers a good vantage point for taking photos of seabirds skimming the waves or the ever-changing patterns produced in the water's surface as it begins to ice over at high latitudes.

When on foot, I often refer to detailed topographic maps (with contours marked on them) to find surrounding higher viewpoints. Indeed, many scenic maps now mark good viewpoints and overlooks that are visible from the roadside. In more remote places, however, it may involve climbing a hill, although in mountain resorts I try to hitch a ride on a ski tow or cable car.

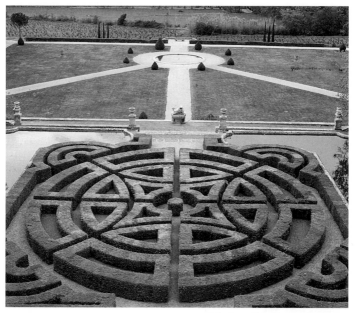

A first-floor window provided enough elevation to take an overview of this magnificent box parterre in a garden near Provence, France.

When working in a garden I often opt to shoot down from an upstairs window so I can see the pattern of a parterre or formal topiary more clearly than from ground level.

If all else fails and the ground is flat enough to erect a step-ladder, I will mount the camera on the high-rise Benbo 5 (Giant XL) tripod, which can be raised up to a height of 99 inches (247.5 cm).

33 Worm's-Eye View

Shooting up towards the sky with a wide-angle from among the leaf litter in a forest adds a bold perspective to trees—especially if they are ancient specimens with irregular branches. This angle can also add drama to a series of large bracket fungi growing on

a tree trunk. In more open situations such as parks, meadows, or prairies, a low viewpoint adds impact not only to solitary trees, but also to tall flowers and grasses if they can be isolated against a blue sky. This is especially effective if a polarizing filter is added to darken the sky when taking tall-stemmed white flowers, grasses, or leafless trees encrusted with a thick frost.

Low-angle shots can also be taken of emergent fungi or flowers by looking across the ground with a close-focusing wide-angle lens (add a small extension ring if necessary). It may then be possible to convey the habitat—woodland or mountain—behind the foreground portrait (see Tip 37).

Whatever angle you select, the camera will need to be supported at ground level (see Tip 19). Use a Benbo tripod or one with a short center column (the sliding column on smaller Gitzo models can be replaced with a short, 3-inch stump). Spread the tripod's legs to get the camera low and keep them out of the picture. Short-stemmed flowers or fungi can be taken by mounting the camera on a ground spike.

To avoid getting a crick in your neck while attempting to focus the camera virtually at ground level, it is worth investing in a right-angle viewfinder. In addition, foam or rubber knee pads like those sold in gardening stores help to ease the discomfort when kneeling for long periods (see Tip 90).

34 "Gardening" Tips

We have all seen published pictures with colorful autumnal leaves positioned equidistant from one another on a rock in the middle of a stream or on a bare patch of ground. Anyone who enjoys photographing outside and has half an eye is not going to be hoodwinked into believing that this is anything but a setup! We all know that when leaves drop naturally, their arrangement is haphazard. As well as arranged leaves, I have also seen pictures of solitary fungi transplanted into more attractive—but totally erroneous—groupings. It is sad, therefore, that deskbound art

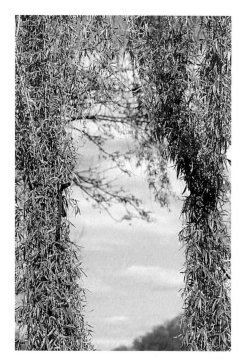

Ribbon or string can be used to temporarily tie back a curtain of weeping willow branches to provide a clear window for working with a long lens.

editors don't seem to recognize a manipulated picture when they see one.

Nature photographers generally consider "gardening" to be a practice that involves the judicious removal of distracting natural objects—whether they be branches, dry grasses, or leaves—from the field of view. But here I use the term to also include the addition of objects to the field of view.

There are purists who argue that nothing should be touched and that every nature picture should be taken without any intervention by the photographer. I personally have no qualms about moving any debris that could be shifted by the next wind. But on the other hand, the odd leaf, acorn, or pine cone left *in situ* conveys the habitat as well as provides a sense of scale. Each subject I shoot must be carefully appraised.

Resist the temptation to over-garden objects out of the field of view; it won't look natural. More than once I have had to abandon photographing a tall solitary flower spike in a meadow that

had every blade of grass around it cut to the ground by a previous photographer!

In the past, many pictures appeared with obvious, recently clean-cut branches around a bird's nest—proof that the photographer left the eggs or nestlings exposed to the elements or predators after getting the shot. Fortunately, attitudes to nest photography have changed. If a branch mars a landscape (or any composition) by cutting across the field of view and cannot be cropped simply by altering the camera's position, string can be used to tie it back temporarily to another branch. Elasticized shock cord, sold in trekking stores, works well for controlling woody branches.

When to Keep Your Viewpoint

35

The techniques for recording short-term action sequences ranging from a matter of seconds to several days are covered in Tip 86. Longer-term changes within the natural world, which span months (a deciduous tree or a landscape changing through the seasons) or even years (succession of vegetation after a fire, a hurricane, or a volcanic eruption), can still form a photo sequence, albeit an extended one.

For taking subjects such as these, a continuous motor drive is superfluous; indeed, the price tag of the camera is immaterial. Instead, for any time-lapse sequence to succeed, it is crucial that all variable parameters (camera viewpoint, angle of view, focal length, and depth of field) remain constant so the seasonal or biological changes are immediately apparent in the photos.* And after several months or more, you can't rely on your tripod marks still being visible from one visit to another! So, after taking the first shot of a fixed-point time-lapse sequence, I record the focal length of the lens, the focusing distance, and the aperture used. I also note any distant objects, such as a rock or a tree, that line up behind foreground features. All this helps me to arrive at approximately the right spot every time.

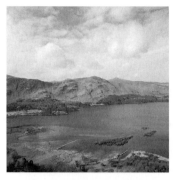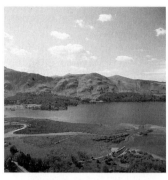

Two shots taken from an identical viewpoint in the English Lake District show how the landscape changes with the seasons. In March (left), heavy winter rainfall fills the lake so that it overflows into the river, whereas by May (right), when the water has subsided, the river's course is clearly apparent.

To ensure I frame the composition in precisely the same way, I refer either to a Polaroid® print taken with a Hasselblad camera (if I am shooting medium-format) or to a color laser print made from a 35mm transparency. Either way, I place the print in a plastic pocket to protect it from rain or snow when I make a return visit.

*In temperate latitudes, the angle and quality of the lighting will obviously vary with the seasons. This is not a major problem, since it can help to convey the seasonal weather, but preferably the same aperture should be used throughout the series so the depth of field remains constant.

36 Find a Frame

Composing a picture with a natural frame lures the eye towards a focal point within it and also helps convey a third dimension. Natural frames exist as rock arches and bridges, canyon walls, overhanging boughs, and holes in trunks of ancient rotting trees.

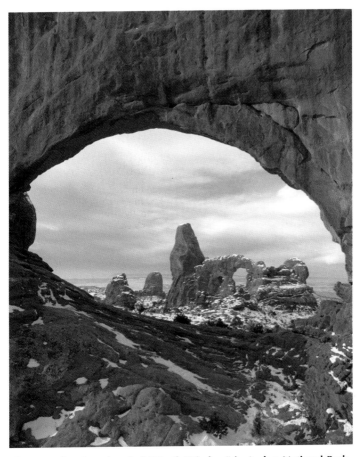

The natural rock arch called "North Window" in Arches National Park, Utah, makes a perfect frame for "Turret Arch" beyond.

I have used natural rock arches to frame inland views in China's Stone Forest in Yunnan and in Arches National Park in Utah (which has the highest concentration of natural arches in the world). In both Arches N. P. and Portimão, Portugal (where marine arches are found along the coast), I've used one arch to frame another more distant one.

On the floor of a gorge or canyon, high-rise walls make vertical frames on each side of the picture. Towering pinnacles, stacks, or buttes also make effective side frames.

Wildlife studies become intimate cameos if they are framed by out-of-focus branches on either side, although this technique works only if the branches occupy a small part of the frame. It fails totally if large heavy branches dominate an image of a distant minute bird or mammal.

37 Portraits vs. Eco-Pictures

When a long telephoto lens has been purchased, there is a temptation to strive for frame-filling face-to-face portraits of animals. Indeed, this is the sort of picture often selected for magazine covers. But why limit yourself to this? I admit I have several of these kinds of pictures in my stock library, but I don't regard taking them as a challenge because they give no information about the environment in which the animal lives. (Indeed, they could be an animal in a zoo or a captive-bred animal in a game farm.)

What I enjoy most is composing pictures of one or more animals when they occupy quite a small part of the frame—but with their habitat clearly visible. I coin this genre my "eco-pictures." Though I relish taking such pictures, they rarely have enough impact to make a cover; they are, however, useful for a scene-setting double-page spread.

Eco-pictures are not produced simply as a result of a reflex action—grabbing the longest lens available, focusing it, and taking the picture. Instead, decisions have to be made about which lens to use and, if the animals are moving into the landscape, at what moment to release the shutter. Many photographers produce eco-pictures by using a wide-angle lens to focus at close range, for example, on an alpine plant, with a mountain backdrop behind. However, with the exception of nesting sea birds, relatively few really wild and free animals will tolerate such a close encounter with a wide-angle lens.

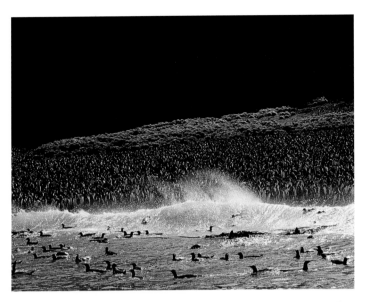

An inflatable boat gave me a perfect low-angled view of king penquins against the light as they surfed off Macquarie Island in the Southern Ocean. In any case, with standing room at a premium, landing on this beach is forbidden.

EVERY THURSDAY **ONLY £1.35**

JANUARY 21, 1995

AMATEUR PHOTOGRAPHER

Emperors of Antarctica
Heather Angel writes about 'the most magical experience on earth'

FIRST TEST
SIGMA'S SECOND GENERATION SLR

A COMPACT GUIDE TO COMPACT CAMERA ACCESSORIES

PLUS: MY FAVOURITE PLACE • TECHNIQUE A WEEK
MINOLTA X9 MINI TEST • MIKE MALONEY • ASK THE EXPERTS

03 >

9 770002 684065

SHOOTING
TIPS AND HINTS

 38 | **Market Research**

Whether you are shooting landscapes, wildlife, plants, or close-ups, the lens you choose and the way you decide to frame a shot should be influenced by the way you plan to use the picture. Good clear portraits, for example, are ideal for textbooks and maybe some magazine illustrations; bold colors and strong shapes portraying classic, iconic themes are suitable for advertising, yet relatively simple lines and subtle colors can appeal as fine art prints.

When I was commissioned to shoot the 1987 Kodak (U.K.) Calendar on the River Thames, I can recall my art editor saying to me, "Every picture must be as attractive and appealing on day 31 as on day 1." I have never forgotten this and think of it whenever I shoot potential calendar pictures or pull images from our stock library.

Magazine and book covers not only have to be strong enough to motivate a prospective buyer to pick them up and browse inside, but also when bled to the edges, the picture must provide enough negative space for overprinting the masthead or title. Therefore, working in one area or concentrating on one kind of animal over a period of several days will increase the chances of taking different pictures and hence broaden the scope for selling pictures to varied markets.

◀ **Plan the frame of a vertical shot to have negative space at the top so that publishers have room to print the magazine's masthead and highlight feature articles.**

On the other hand, producing photographs with the sole objective of seeing them reproduced as fine art prints offers no such constraints and therefore allows much greater scope for individual expression.

 # 39 | Dusk and Dawn

The prime time for taking classic dawn and dusk shots is telescoped into a few brief minutes at the beginning and end of each day before the sun rises or after it has sunk below the horizon. During those magical moments (providing the sun's rays are not obscured by clouds), the sky is transformed by glorious—but sadly ephemeral—colored hues. Depending on the latitude, the clarity of the atmosphere, and the time of year, these colors could be delicate pink, pale orange, intense orange, red, magenta, or even deep blue. But capturing these beautiful skies can be tricky.

Pictures that include the sun's orb in the frame as it rises or sets can be disappointing because transparency films simply don't have the latitude to cope with the exposure extremes between the intense brightness of the sun and the dark shadows on land. However, when sky and water fill the frame so that the water takes on the sky's color, or when dust particles are prevalent in the atmosphere, the contrast between the sky and land is decreased, making a more pleasing image that falls within the film's latitude. On the other hand, high contrast can be used to your advantage if an object such as a tree, leaping dolphin, or whale is used to block the direct rays of the sun, thus creating a silhouette (see Tip 44).

So what do you meter on? Depending on the intensity of the sky or cloud color, I spot meter the sky alone (no land included) and either use the exposure, or, if it is brighter than an average tone, I will open up 1/2 to 1 stop. With sunrises and sunsets it is not always possible to judge what exposure will give the best result, so here is one of the rare instances when I would bracket 1/2 stop either way. Since the light level is constantly changing, the

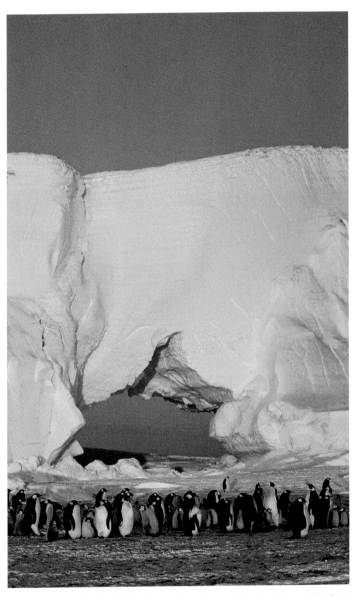

Emperor penguins huddle in front of an ice arch bathed in a pink glow as the sun sinks towards the Antarctic horizon.

71

exposure has to be revised at frequent intervals. When the sun is above the horizon, make sure to exclude it when you meter the sky. I tend to use a medium-long lens (such as 200 or 300mm) and spot meter the sky to one side of the sun.

Since sunrises and sunsets are over so quickly, there is no fudging it; you have to be in the right place at the right time to catch a fiery glow as it beams directly onto clouds, mountain peaks, or even is reflected in otherwise drab water. To optimize these moments, you will need to determine the precise time of sunrise and sunset so you can be in position well beforehand. Most newspapers publish the times for sunrise and sunset on their weather page. Or, if you have a Global Positioning System (GPS) receiver and it's programmed correctly, some models can provide times of sunrise or sunset for any given location.

Even armed with this information, it is well worth investing time in advance to seek out the best viewpoints and appropriate lenses. In places such as Yosemite or Grand Teton national parks, the photographic meccas are easy to locate by the gaggles of photographers that congregate at dawn and dusk erecting their tripods at viewpoints such as Half Dome or the Snake River over-look immortalized by Ansel Adams.

40 | Reduce Your Speed

It is totally impractical to carry a range of film speeds to meet every eventuality on a long trip. Now that we have superb defini-tion with ISO 100 speed transparency emulsions, I tend to stick with two speeds, ISO 100 and 200, as my standard stock except in extreme low-light conditions (see Tip 85). These films work well for 99% of the situations I shoot in, because I almost always use a tripod.

If my film is not slow enough to gain a longer shutter speed to blur moving water (see Tip 43), I use a neutral-density (ND) filter to reduce the amount of light reaching the film. I carry rectangu-lar ND2 (lose 2 stops) and ND4 (lose 4 stops) Cokin® filters.

Either can be dropped into the professional ("P") holder with a screw-in adapter for mounting it on the lens. This is a much cheaper option than buying individual screw-on filters for various lens diameters for both 35mm and medium-format systems.

Without an ND filter you can reduce the film speed by "pulling" (setting a lower ISO number) the whole roll of film by one stop (this is the opposite of "pushing"; see Tip 85). However, for my money, using a filter is the preferred option because you won't affect the entire roll, no special processing is required, and there is no additional processing charge.

41 Change Your Perspective

When a camera—particularly with a wide-angle lens—is tilted rather than kept horizontal, the perspective of vertical lines is distorted. If the camera is tilted skywards, straight tree trunks growing closely together will converge towards the center of the frame, whereas if it is tilted down from a high viewpoint, the verticals will diverge.

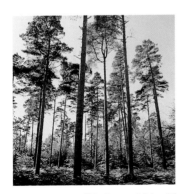
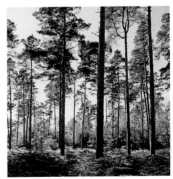

Tilting a Hasselblad 500 C/M with a 60mm lens toward the sky causes the pine trunks to converge (left). This perspective distortion is corrected by using the shift function on a Hasselblad FlexBody (right).

When perspective distortion is deliberately sought and used to exaggerate the foreground mass and reduce the size of distant objects, it can produce a graphically hard-hitting image. On the other hand, in situations where subject perspective distortion spoils the composition, moving farther away from the subject is not feasible, and you don't have a 4 x 5 view camera with shift and tilt movements, the solution is to use a perspective control (PC) lens. These so-called "shift" lenses, produced by the main SLR camera manufacturers, correct perspective distortion by moving the lens instead of the camera. Canon goes one better with lenses that both tilt *and* shift (24mm, 45mm, and 90mm TS-E lenses) (see Tip 42).

If you are already a Hasselblad owner, it would be worth considering either renting or buying their FlexBody, which weighs a mere 1.5 lb. (700 g); it has both shift and tilt functions and is priced around the mid-range of the 35mm format PC lenses. Nearly all the existing Hasselblad lenses and magazines can be used with the FlexBody, which makes it much more versatile than any of the fixed PC lenses available for 35mm format.

Although shift lenses were originally designed for architectural photographers, I find them invaluable when working in small gardens, whether I am shooting from the ground looking up or from a window looking down. The correction is made by moving the lens (or the body, in the case of the FlexBody) a few millimeters up or down. A lateral movement is achieved when using a PC lens on a 35mm format by rotating the lens 90° in its mount.

42 Increase Depth of Field

Large-format cameras not only use a much larger area of film than medium-format or 35mm cameras, most also possess shift and tilt mechanisms. However, both these features are now available on the Hasselblad FlexBody and the Canon TS-E (tilt and shift) series of lenses. The shift movements, whereby the lens remains parallel to the film plane, are used for correcting converging or

Only a narrow zone of the image appears sharp when a Hasselblad with an 80mm lens is angled down onto a carpet of leaves (left). The tilt function on a Hasselblad FlexBody increases the depth of field so that the entire frame appears sharp (right).

diverging verticals (see Tip 41), whereas tilting the lens (or the FlexBody) increases the depth of field.

If you have access to the Hasselblad system, the FlexBody is much more versatile than the Canon lenses, because it can be used with any Hasselblad CF lens from 50 to 250mm—although the amount of shift is less with wide-angle lenses than with the standard 80mm and longer lenses.

However, it is the tilt function that is so appealing to landscape and nature photographers alike. By tilting the body (and hence the film back), the sharpness zone of a flat surface is increased to a much greater extent than is possible by stopping down the lens alone. This enables floral carpets or fallen leaves within a receding plane to be brought into focus throughout the entire frame. The beauty of this tilt movement is that you don't need to use the smallest possible aperture, so you can get away with using faster shutter speeds when the wind is blowing. With a conventional camera body, even if you utilize the hyperfocal distance (see Tip 29) and stop the lens down to get a reasonable depth of field, it won't be so extensive and, what is more, you inevitably end up using a slow shutter speed with fine-grain film.

43 | Work Magic with Water

Water has magical qualities that can add a dramatic element to many a landscape photograph. On the one hand, still water is chameleon-like in mirroring its surroundings. Often the reflection alone, particularly if it is partially distorted by ripples, makes for a more eye-catching picture than the subject with its reflection. On the other hand, streams and rivers introduce a mobile element to a static scene.

The motion can be frozen with a fast shutter speed or blurred with a slow one. In bright sunlight, even when using a slow film, a slow shutter speed may not be possible unless a neutral-density filter (see Tip 40) is used. However, on a dull day and especially inside forests, very slow shutter speeds of a second or more will blur the moving water into streaked lines of motion. Using slow speeds to take moving water is most effective when the volume of water is not too great, so that it appears like a translucent veil cascading over rocks. By comparison, when heavy water flows are photographed using slow shutter speeds, they are transformed into white expanses.

A one-second exposure was used to create blurred, impressionistic images of koi swimming in a pool in Japan.

Search for floriferous shrubs in spring and summer or colorful trees in fall growing beside a body of water. For a few brief moments at dawn or dusk the reflection of a colorful sky can greatly enhance a colorless watery expanse (see Tip 39), or a slow shutter speed can be used to take colorful fish swimming near the water's surface or fallen leaves carried by moving water, so they are transformed into impressionistic streaks of color within their aquatic environment.

 # 44 | Shoot Silhouettes

The art of distilling shapes of objects into solid black images dates back to the 18th century. Long before the invention of photography, a French politician—Étienne de Silhouette—made portraits of people by cutting out their profiles from black paper.

Producing silhouettes using a camera is easy, providing certain criteria are met. The first essential is to find a subject set against an uncluttered, brightly lit background. Silhouettes taken against a colorful sky when the sun is below the horizon at dawn

As a pair of bottle-nosed dolphins leap from the sea against the setting Honduran sun, they create curvaceous silhouettes.

or dusk are especially eye-catching, but also look for shapes silhouetted against water, snow, or white sand dunes. Whatever the subject, silhouettes force the eye to focus on shape without being distracted by color or texture.

To ensure that no hint of surface texture is visible, expose for the bright background and keep the composition simple. Avoid having other objects—whether trees or animals—overlap the subject. Mammals are best viewed with their side to the camera so that their distinguishing features, such as the shape of their ears, horns, or tail, or the length of their neck or legs are immediately obvious. Birds flying in a line or mammals moving in single file make for more recognizable silhouettes than a group of animals standing in front of one another. Whales or dolphins leaping out of the sea provide curvaceous movement to a silhouette.

Mountains with irregular profiles also work well. A succession of ranges taken early or late in the day can produce a series of receding planes from a solid black silhouette in the foreground to a pale gray mountain range in the distance.

 # 45 | Mist Opportunities

One of the most eerie (and frustrating!) sensations I have experienced is being in a boat at sea completely enveloped in mist, hearing killer whales surfacing and blowing close by, yet being unable to even glimpse them.

Mist adds an ethereal, atmospheric quality to a landscape, creating pale tones and pastel colors to produce "high-key" pictures in contrast to the well-saturated colors and distinct shadows of a "low-key" scene bathed in direct sunlight. Where mist spreads over a large area it functions like a huge diffuser, softening sunlight and shadows or even obliterating shadows altogether.

When warm moist air passes over cold ground or is cooled at night, mist or fog forms as the moisture condenses into minute water particles. Localized pockets of mist develop above rivers and ponds or in damp hollows, whereas extensive misty areas

may form in forests or at sea. In mountainous regions, mist and low clouds may swirl constantly around peaks.

When the skies are clear above the mist, you have to work quickly before the sun comes up and begins to warm the air, causing the water droplets to evaporate and the mist to thin out. As mist develops, foreground objects such as trees, clumps of flowers, deer, or whales take on a greater significance compared to the background, which appears pale and indistinct as it fades away into a haze. I have used mist to help isolate trees in a rain forest and snow monkeys in Japan. When photographing in thick mist, it is essential to position your camera as close as possible to your subject (and then choose the appropriate lens for the desired shot) in order to get a well-defined foreground subject.

Mist is also invaluable for blotting out unsightly backgrounds and eyesores that cannot be hidden or moved out of shot by changing the camera's viewpoint. As humanity invades wilderness areas, its presence becomes all too evident in the form of roads, telegraph wires, electric cables, and television aerials.

Early morning mist behind an ancient pollarded oak serves to enhance the tree's sinister impression. Using a 20mm lens helped accentuate its distorted limbs.

TIPS AND HINTS FOR MODIFYING LIGHTING

 46 **Quick Fixes for Filters**

When the chips are down and you know you have only a matter of seconds to capture a spectacular landscape before the clouds roll in, the last thing you want to do is waste time attaching a filter. Even worse is finding that you don't have the right size fiter for the lens you are using! Holding the filter flush against the lens is one solution, but then there is always the risk of causing vibration during a long exposure.

A quick and effective way of fixing a glass filter to the front of your lens is by placing a couple of small pieces of adhesive putty on opposite sides of the lens (the filter has to be larger than the diameter of the lens you want to use). This may not look very attractive, but it works, and what's more, it leaves you with both hands free!

This method functions well for all filters except for polarizers because it is difficult to put any pressure on the outer ring to rotate it without dislodging the filter. The solution: Hold the filter in front of your eye and rotate it to gauge the position that achieves the effect you desire. Mark the position of the top of the ring with a strip of white tape. This also aids in using a polarizer with a Hasselblad Superwide (which does not have a pentaprism, making it impossible to view the effect of the polarizer through the lens).

Another solution is to use a square filter, such as those made by Cokin, which simply slides into a filter holder or a bellows lens hood, both of which screw directly into the lens mount. Cokin's

◄▥ **A reflector was used to direct light onto flowers that were shaded by overhead leaves.**

Adhesive putty or modeling clay can be used to quickly attach a filter to a lens.

square filter system goes a step further by offering a round polarizer that fits into their filter holder. Both filter and holder are designed so that the polarizer can be easily rotated. Because there are several slots in the filter holder, the polarizer can be used in conjunction with other Cokin creative filters to enhance their effect.

 47 **Polarizers: The Most Versatile Filters**

A polarizing filter is not just for darkening blue skies (thereby creating increased contrast in the white clouds, white rocks, or even tall-stemmed white flowers), it is also invaluable for reducing skylight reflections, which can increase the color saturation of

vegetation. Partial polarization can help tone down reflections in shiny leaves and fruits, which can be conspicuous in a close-up (however, complete removal of highlights from glossy leaves such as holly looks unnatural).

The effect of a polarizing filter is most obvious when shooting at 90° to the sun (i.e., when you are looking straight ahead, the sun is either on your left or right), but it can also be used to reduce glare on leaves when shooting at any angle—including directly into the light.

A quick way to judge whether a polarizing filter is worth using without going to the trouble of removing a lens hood and attaching the filter is simply to rotate it in front of your eyes. As the myriad skylight reflections on leaves or grasses disappear, the overall color—whether green or autumnal hues—is enriched. Likewise, the color of submerged plants (or fish) becomes enhanced as the water' s milky surface reflection disappears with increased polarization.

The only drawback is that when a scene is fully polarized, there is a light loss of 1-1/2 stops. This may not sound like very much, but when a slow-speed film is used and the unpolarized exposure is, say, 1/125 second at f/8, this means you either have to sacrifice depth of field by opening up the aperture by 1-1/2 stops (to between f/5.6 and f/4), or if you wish to keep the same aperture of f/8, resort to a slower shutter speed of 1/45 second.

Polarizing filters are not cheap, and if you have many lenses with different diameters, either buy one that will cover several lenses without any risk of vignetting at the frame edges and fix it to the lens using adhesive putty (see Tip 46) or a step-up ring, or use a polarizer, such as one made by Cokin, which drops into a professional ("P") holder with screw-in adapters to fit each particular lens. Fast 300, 400, 500, and 600mm lenses have large external diameters, which make for pricey front-fit filters. But these lenses often have a filter slot in the lens barrel, designed to take much smaller diameter drop-in filters. A few words of caution: When lenses wider than 28mm are used, their angle of view is too great for a filter to uniformly polarize the sky, which makes the sky appear patchy.

Polarizing filters come in two types: linear and circular. The former can erroneously affect spot meter readings and can adversely affect the autofocus systems of AF cameras. (Kirk

A comparison of unpolarized lily pads (above) with polarized pads (below) demonstrates how a polarizing filter increases color saturation by removing skylight reflections.

Enterprises makes 39mm drop-in circular polarizers for some long Nikkor lenses, which, unlike linear polarizing filters, will not affect the camera's spot metering system.)

 ## 48 Reduce Contrast with Filters

Color transparency film simply does not have the latitude to correctly expose a landscape including both a 100% bright, white, cloudy sky and the land below. In such situations you have three options: include the white sky, crop out the sky from the landscape, or use a graduated filter to reduce the contrast between the sky and the land.

Graduated filters have a colored half that gradually fades into a transparent area, and they are available in various colors. But only the neutral-density grad adds density while maintaining authentic color in a cloudy, colorless sky. Although blue is a natural color for sky, it does not complement a landscape that lacks shadows, and the tobacco or magenta grad filters are so unnatural they are best left to art directors visualizing advertising shots for cars.

The most versatile are the square filters, such as Cokin professional ("P") types, which can be adjusted within the filter holder to suit each composition. Even then, there are situations when graduated filters won't produce good results, such as when the horizon is punctuated by trees or peaks. Galen Rowell neutral-density graduated filters (which fit Cokin "P" holders) are available in either soft-step or hard-step graduation, used respectively where gradual or sharply defined light boundaries are required.

Screw-in grad filters are more inflexible than drop-in types. Since the color strip cannot be moved, it dictates the position of the horizon within the frame and hence the composition of the picture.

49 Lighten Up!

Knowing when and how to modify available light is paramount to rendering any photographic subject successfully. Light that falls on a broad scene such as a landscape, group of animals, or trees can be altered by means of lens filters, whereas light falling on close-range subjects such as plant and animal portraits can be modified by using reflectors, diffusers (see Tip 50), or fill flash (see Tip 53).

A reflector is invaluable for boosting available light and filling in harsh shadows. It has the added advantage over flash of allowing you to see precisely the final effect in the viewfinder.

A reflector with a mixture of silver and gold is used to fill in the shadow area on the foliage of this golden yew.

Professional reflectors include the collapsible models made by Lastolite (in the U.K.) and distributed in the U.S. by Westcott® as Illuminator Reflectors. They are made in a choice of finishes: silver, gold, or "sunlite" (a mix of silver and gold—which I think produces the most natural effect). In addition, Photoflex® makes a wide range of round and oval Litediscs.

For lighting still larger areas, large panel reflectors such as California Sunbounce® comes in two different-sized (3 x 4 feet or 6 x 4 feet) rectangular panels that open out into a rigid panel supported by aluminum frames and roll up for carrying in a shoulder bag. They are available in three reflective finishes: silver, gold, and zebra (a silver-and-gold mix).

Makeshift lightweight reflectors include a roll of standard kitchen aluminum foil and the thin, disposable, silver "Space Blankets"—although they need either to be held by an assistant or wrapped around a piece of board or even a photo pack to prevent them from flapping in the wind.

 ## 50 Soften Light with a Diffuser

Photographing a black-and-white subject such as a giant panda in bright sunlight presents problems when transparency film is used. Quite simply, the film does not have the latitude to cope with the extreme tonal range. Photographing pastel-colored flowers is also a problem in harsh light. The solution? Either wait for a cloud to diffuse the sun or soften the light in a specific area by using a diffuser.

Lastolite, Westcott, and Photoflex all make collapsible circular white diffusers in various sizes. Larger diffusion areas can be made using the range of Rosco® diffusion filter gels available in rolls, as used by the film industry, or dressmakers' non-iron white interfacing (see Tip 96). All-round soft, shadowless lighting can be created for static subjects by using a white opaque light tent such as the collapsible models made by Lastolite in the U.K. and distributed

Backlit peonies (above) show more contrast than the even, shadowless light created by holding a diffuser between the sun and the flowers (below). Both methods create strikingly different moods.

by Westcott in the U.S. The diffuser is held between the sun and the subject so that the entire area within the camera's viewfinder is covered by the softened light. This will greatly enhance the detail of fur, feathers, or petals. All diffusers result in some light loss—anything from 1/2 to 1-1/2 stops, depending on the thickness of the material.

51 Don't Get the Blues

If you use slide film to photograph a subject first in direct sunlight and second in indirect sunlight when a cloud passes overhead and then compare the results, the latter will appear to have a distinctly blue cast. Likewise, photos taken beneath a dense overhead forest canopy will also be tinged with blue. While this cast can be used to your advantage when taking photos of certain blue flowers (see Tip 92), it is not appropriate for other subjects.

Fortunately, there are two easy ways to subdue this blue cast in your pictures. Warmer colors can be induced by using a flash to light up a small area or using a straw-colored warming filter within the Kodak 81-series of light-balancing filters when taking in a wider view. These filters are available in three different strengths, from weakest to strongest—81A, 81B, and 81C. Rosco also produces a range of gel filters that have a warming effect.

TIPS AND HINTS
FOR FLASH

Add Life to
Dark Eyes

52

Nothing looks more lifeless than the dark eye of a bird or mammal surrounded by dark feathers or fur without any hint of a catchlight. On a sunny day all that may be needed is patience. Wait until the animal turns its head so that a natural highlight appears. Even on a dull day, if the animal raises its head skyward, this may be enough to produce a skylight reflection in the eye.

But for those animals that persist in taking evasive action to prevent the sun from shining on their faces (and who can blame them?) or those that frequent shady locations, you will need to create a highlight in their dark eyes. When using fill flash (see Tip 53) this will happen automatically, but a small flash unit with a low guide number (or even a pop-up flash on a camera) can also be used to produce a catchlight in the eye without affecting the overall exposure. Since the output of a small flash is secondary to the amount of available light, it can even be used on-camera without fear of producing red-eye or a harsh direct lighting effect.

◀▥ A twin-flash setup was used to rimlight this grass snake's extended tongue.

Fill flash was used to add catchlights to this panda's dark eyes, giving its face expression. (C)

Fill Flash

Before automatic dedicated flash units that meter directly off the film plane became available, I used to have to make my fill flash calculations on the back of a film pack. Now such TTL (through-

Fill flash was used in this backlit shot to reveal the natural colors of a cock kingfisher resting on a post.

the-lens) flash units have revolutionized flash photography in the field. During daylight hours a TTL flash is an invaluable tool in several subtle ways:

❑ It provides a catchlight to a dark-eyed bird or mammal (see Tip 52).
❑ It fills in shadow areas.
❑ It illuminates recessed areas.
❑ It can correct a warm cast on a pastel-toned subject early or late in the day.
❑ It can correct a cold, blue cast.
❑ It makes creative slow-sync flash possible.

The two crucial points to remember are that the exposure is based on the available light, and fill flash can be used with any shutter speed ranging from your camera's fastest possible flash sync speed to any slower speed, depending on how fast the subject is moving.

For a straightforward fill flash photo of a plant or a fairly static animal, I meter the subject and decide what combination of aperture and shutter speed is desirable. Then using the exposure compensation button, I reduce the flash output by 1-1/3 to 1-2/3 stops. This ensures that the flash exposure is less powerful than the ambient light exposure and has the advantage that the flash recharges very quickly. The great advantage of using fill flash in this way is that it does not immediately shout "flash photograph." Even if the flash fails to discharge (as can happen after many repetitive flashes in quick succession) no picture is wasted, since the exposure is based on the available light.

Fill flash is still possible with non-TTL auto-flash units, although you then have to devise a way to fool the flash into lowering its output. On some units this can be done by doubling the film speed (i.e., from ISO 100 to 200), which will reduce the flash exposure by one stop. You must, however, be prepared to do some experimentation, since auto-flash exposure is calculated assuming the flash is being used indoors where there is some reflection from walls and ceilings.

With static subjects such as flowers, mosses, lichens, or fungi in a poorly lit location, exposures as long as 1 second or more can be used with fill flash. Remember, though, if fill flash is used with a slow shutter speed to take a moving subject, a ghostly blurred image will be recorded in addition to the sharply defined

flash-lit image. This blur can be a distraction when taking a flower blowing in the wind, whereas deliberate use of slow-sync flash can be a highly creative way of taking an animal in motion. A bird such as a gull, which maintains its position by flapping its wings, will be frozen by the flash, with ghostly images of the wings in different positions as they moved during the long exposure. You have to be prepared to shoot quite a few frames, since it is a matter of luck whether the composition works or not.

Another way to use slow-sync flash is to pre-focus the camera and pan it in the same direction as the moving animal (see Tip 84) using a shutter speed of 1/30 to 1/2 second. The best effect will be gained by using rear- (instead of front-) curtain sync, so that a moving animal is recorded as a crisp image *followed by* streaks of movement.

Working in the Dark

Successful wildlife photography is not exactly a piece of cake by day, but when we venture out at night, we are hugely disadvantaged compared with nocturnal animals. Equipped with senses that function best by day, we strive to compete with animals that have developed ways to move and feed efficiently during the cover of darkness. It's no wonder that the probability of our achieving a successful photograph is low. Unless nocturnal animals have been gradually habituated to a continuous light source (such as geckos in houses) they will have to be photographed using one or more flash units.

Approachable nocturnal insects, spiders, amphibians, and smaller mammals such as spring hares can be located by using a flashlight and photographed simply by handholding a camera mounted onto a flash bracket complete with a flash (see Tip 58). My husband helps me photograph frogs at night by panning a flashlight to locate one that is calling. When I get within shooting distance, he momentarily spotlights the frog so I can focus the lens manually.

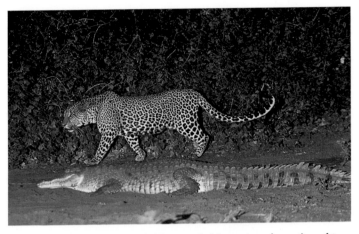

Flash was essential to record this remarkable nocturnal meeting of two predators—a crocodile and a leopard—at Samburu, Kenya.

Nocturnal animals will tolerate red light, therefore another solution is to use a flashlight covered with red cellophane. Providing there are no brighter-than-average rocks or leaves in the picture, I know I can rely on the dedicated TTL Nikon SB-24 flash to produce a correct exposure.

Photographing most nocturnal birds and mammals, however, is not nearly so straightforward. Remember, mammals generally have an acute sense of smell, so before setting up any lights, you need to select a camera position downwind of the subject or else use a platform raised well above the ground. Wear subdued nonreflective clothing that does not rustle every time you move, and make sure all shiny parts of the camera and tripod are masked with dark, matte tape before you set out on a nocturnal shoot.

It is ironic that while we can see better at night under a full moon, true nocturnal animals tend to be much less active at this phase. Either you need to invest time in the field getting to know the place and hour when these animals are likely to appear, or else work with a naturalist who is familiar with the animals' haunts.

The advantage of photographing a ground-dwelling nocturnal animal, such as a badger or fox, which habitually uses the same hole to emerge at night, is that creative lighting can be arranged

before it appears. For example, one or two flash units can be set up to backlight the animal, while another on reduced power arranged to light the front will prevent a complete silhouette. The camera should also be set up before darkness falls and be prefocused manually. Although AF systems will function in extremely low light down to EV −1, they do need contrast to function. Any AF lens that persistently "hunts" (apart from those with silent motors) will more than likely disturb an animal, and suddenly illuminating a nocturnal subject is a sure way to send it bolting down its hole or speeding off into the darkness.

Several flash heads will give better modeling than a single one. To reduce potential hazards for yourself and wild mammals, try to eliminate all flash sync cords except for the one connecting the flash to the camera, and fire the other heads using slave units.

Clean Up Your Syncs!

55

There is nothing more frustrating than fixing the camera to a tripod, focusing, and framing the shot only to find that the flash fails to fire. Aside from dead batteries, a frequent cause of malfunction when an off-camera flash is used is that the flash sync cords fail to make a good contact.

Basic flash extension (PC) cords that connect a flash with a camera are particularly vulnerable to surface corrosion if the contacts get wet. When not in use, they should be stowed in self-sealing storage bags. I always carry a few safety pins or metal paper clips (only ones with rough-cut ends will work) inside a film canister in my fixit kit (see Tip 4) to scrape away any surface deposit that might have built up. A pen-shaped battery contact cleaner, available from L. L. Rue's catalog, will also work for cleaning PC contacts.

Dedicated flash cords that are connected to the camera via the hot shoe contact are less prone to corrosion because they do not have a recessed socket, but nonetheless care must be taken not to trail the ends of the cords through wet grass or accidentally dip them in a pond or (worse still) into sea water.

Reduce Recycling Time

56

Accessory flash units are great when they work, but when shots are lost due to faulty sync cords, dirty contacts (see Tip 55), or the recycling rate being too slow, then frustration begins to set in with a vengeance.

First, check that everything is working before going out on location where flash is essential to the success of your primary goal. Take a spare sync cord too. Second, invest in a separate power pack that speeds up the flash recycling rate compared to alkaline batteries.

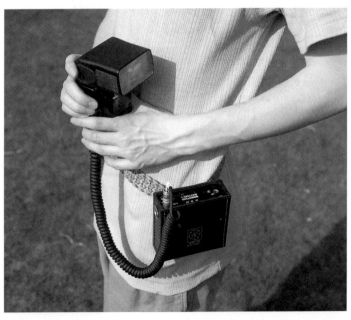

A Quantum battery pack (carried clipped onto a belt) speeds up flash recycling time and provides more flash bursts than alkaline batteries.

For years I have used a portable Quantum battery power pack, complete with a substantial clip for attaching it to a belt, making it secure when working on the hoof. This gives me considerably faster recycling times *plus* many more full-power shots than are possible from one set of alkaline batteries. Each pack has a series of indicator lights that tell you at a glance how much power still remains in the pack (full, 3/4, 1/2, or none). To connect the power pack to your flash you will need to buy a module to fit inside the battery compartment. The compact (14 oz. [397 g]) Bantam battery pack by Quantum is small enough to be carried in a photo vest or mounted beneath the camera or onto a flash bracket. Chargers for use in vehicles or ones that fit the multifarious-shaped electric sockets dotted around the world are available.

Creative Flash Setups

57

It may be easy to use a flash as though it were permanently welded to the camera's hot shoe, but it certainly isn't creative. Using the flash off-camera not only produces better modeling, it also reduces the chance of red-eye (see Tip 60).

When working with a static subject (such as a plant) or an animal that has a fixed home base (such as a nesting bird or badgers at their den), one or more flash units can be set up remote from the camera. Within a forest it may be possible to utilize a tree trunk as a very solid and tall flash support. The TreePod, complete with panhead and rotational arms, although designed principally for mounting a scope, camera, or video camera, also makes a versatile flash support when working in a forest. So, too, does a Bogen/Manfrotto quick-release clamp or Magic Arm, either of which can be clamped to a small branch or connected to a pole strapped to a tree trunk.

When faced with a treeless habitat with soft ground, the flash can be attached to a Bogen/Manfrotto Swivel Umbrella Adapter mounted on top of a metal or wooden spike pushed into the

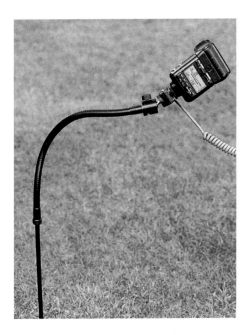

A swan-neck flexi-arm attached to a spike makes a light-weight but versatile stationary flash support.

ground (see Tip 19). An alternative flash support is a small tripod such as a Benbo Low-Boy. When photographing plants I may use a Polaroid back on a Hasselblad to check that there are no distracting reflections from wet or shiny parts and that the shadows created by the flash don't dominate.

If flash units are going to be left unattended for any length of time, they should be enclosed in tough plastic sheeting and sealed with elastic bands to ensure that they are completely weatherproofed. Likewise, all flash connections need to be sealed with weatherproof tape.

A twin-flash setup will provide more creative lighting than a single off-camera flash, which will induce conspicuous shadows. The most powerful flash is used to provide modeling to one side and above the subject, while the other flash is set to give 1-1/2 to 2 stops less exposure so that it simply fills in the shadows cast by the main flash.

See Tip 54 for guidance on how to use static flash at night for taking nocturnal animals.

Flash to Go

Setting up a fixed flash remote from the camera (see Tip 57) is fine if you can predetermine the camera's position, but it is completely impractical for taking mobile subjects such as insects, or birds and mammals that are away from their nest or home. By carrying the camera and flash mounted together as a single unit with the aid of a flash bracket it is possible to approach groups of butterflies drinking on moist ground, birds attracted to a food source, or nocturnal animals with ease. With the camera and flash always at the ready, a high proportion of successful pictures should be achieved.

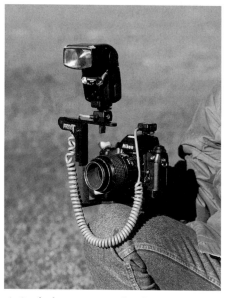

A Stroboframe Press-T bracket offers lightweight mobile flash support.

A range of brackets are available, which vary in height, weight, mount, format, and grip style. Choose a bracket that, together with the camera and flash unit, will not cause muscle fatigue to set in, yet is strong enough to adequately support the weight of them both without collapsing. If you shoot more than one format, select a bracket that will fit both camera systems. Stroboframe® has designed flash brackets for use with most 35mm or medium-format cameras and flash units. They manage

to be robust without being weighty. The Stroboframe Pro-T and Press-T models are designed so that the camera, not the bracket, is held for more natural shooting in both horizontal and vertical formats.

Tip 100 describes a twin-flash setup suitable for macro work.

Indirect Flash

59

Directing a naked flash onto glossy-coated fruits, birds with an obvious sheen to their feathers, or any animal with a wet covering will induce conspicuous highlights that can be very distracting. So the question is, how best to soften direct light and harsh shadows?

Setting up a white umbrella for bouncing the flash's light when working out in the field used to be both fiddly and time-consuming—not to mention totally impractical for taking wildlife. But now there are several ready-made lightweight flash diffusers available. The least sophisticated, but arguably the most convenient

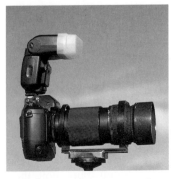

A Sto-Fen Omni Bounce attachment slips over the flash window and diffuses the light from the flash.

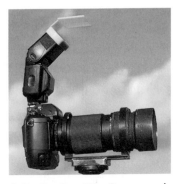

A Sto-Fen Two-Way Bounce positioned for bounce flash.

(since it can be kept in place on the flash itself) is the Sto-Fen® Omni Bounce® (this resembles the translucent lid on some slide boxes in which mounted 35mm slides are returned from processing). This device snaps snugly over the head of a portable flash without the need for sticky tape or hook-and-loop strips. What's more, the automated mode of the flash still functions. The Sto-Fen Two-Way Bounce originates from the same stable and also fits onto the flash head. The adapter is positioned with the mounting slot towards the back of the flash for bounce use (with the flash head tilted to 75°) and towards the front for shoot-through (flash head at 45°).

Most other models are secured to portable flash units by means of hook-and-loop strips. The lightest softbox I have found is the Photoflex on-camera inflatable Extra Small Litedome XTC™ (1.6 oz. [46 g]) with a front diffusion area of 6 x 8 in. The West-cott Micro-Apollo™ light modifier complete with a slip-over bag weighs in at 2.6 oz. (74 g), while the Lumiquest® Promax SoftBox weighs 3.6 oz. (102 g).

Both the Photoflex Litedome and the Lumiquest Promax Soft-Box are designed with an inverted V cut away at the base, which ensures the sensor on the flash unit is not obscured. Lumiquest also makes a wide range of reflectors for portable flash units.

All flash diffusers will result in some light loss (anywhere from 1 to 2-1/2 stops), but any camera with TTL metering will automatically compensate for this.

Red-Eye: Reduce It or Use It

60

When an on-camera flash is used to take portraits of people, mammals, or birds facing the camera, in dim light their pupils will be dilated and their eyes will appear to glow an unflattering red (many mammals) or green (birds and some mammals) as a result of the flash reflecting off the back of their retina. Fortunately, there are several ways in which this problem can be solved. To prevent these demon-like eyes from appearing on film, either move the flash off-camera with a flash extension cord or use a camera (or a flash) that automatically emits a pre-flash or series of flashes prior to the main flash firing. The subject's dilated pupils respond to these pre-flashes by contracting, so the red-eye is barely discernible.

Pictures already taken showing red-eye need no longer be relegated to the waste bin, since Optex™ produces special re-touching pens. On color prints (but *not* Polaroid prints) the distractions are eliminated by using either a red-eye reduction or a "pet-eye" reduction pen. Unwanted glowing eyes on color transparencies can be removed by scanning the image and using a software program such as Adobe Photoshop® to retouch the eyes, noting in the caption that the picture has been digitally enhanced.

On rare occasions, when faced with a group of animals such as hyenas, hunting dogs, or lions, deliberate underexposure using the flash on the camera to produce an array of glowing red eyes may be a more telling way of illustrating their nocturnal habits than a perfectly exposed flash shot of the animals without red-eye.

Make Flash Go the Distance

61

Portable, dedicated TTL electronic zoom flash units are a god-send for use with any prime or zoom lens having a focal length within the 24mm to 85mm range. Depending on the focal length of the lens attached to the camera, a dedicated flash unit with a zoom head automatically zooms the internal flash lens in or out behind the Fresnel screen covering the flash window. With a wide-angle lens it moves in closer to give a broader angle of coverage; conversely, with a longer lens it moves back so as to produce a beam with a narrow angle, which will light a subject farther away more effectively.

While these flash units can be used for fill flash in conjunction with lenses up to 300mm, they simply will not produce enough power to adequately light a distant subject. The solution is to fit a teleflash to the flash unit. This attachment concentrates the flash via a separate Fresnel lens positioned several inches in front of the flash window into a beam with a narrower angle.

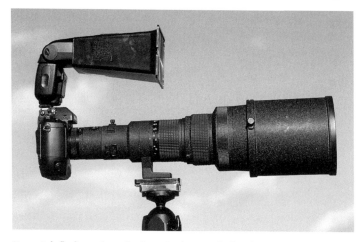

Use a teleflash, such as the Lepp Project-A-Flash, when using a long lens.

Teleflash may, however, increase the likelihood of red-eye (see Tip 60) unless the flash unit is used off-camera.

A variant of the teleflash theme is the Lepp Project-A-Flash, a black polyethylene funnel that fits over the front of a wide range of flash units and is fixed to the head by means of a Velcro connection. At the front of the funnel is a Fresnel lens, which concentrates the flash beam and, providing it is accurately aimed, can increase the flash output by three f/stops when a 300mm lens or longer is used. The increased output of the flash is measured and automatically compensated for by the TTL flash metering inside the camera.

Even though the Project-A-Flash weighs only 6 oz. (170 g), it does increase the stress applied to the hot-shoe mount when the flash is connected directly to the camera, so I prefer to detach it whenever I carry the camera mounted on a tripod in the field.

Painting with Flash

62

With time and much effort, a large enclosed area such as an underground cave can be creatively lit by strategically positioning several flash units behind stalagmites and stalactites and combining this with some front lighting. In a damp cave environment, flash extension leads are hopelessly impractical, and there is always the risk they may appear in the shot, so all remote flash units need to be triggered by a cordless remote control system.

An alternative technique is to literally paint light around an unlit cave by firing multiple flash bursts from a single unit. Painting with flash has long been a popular technique of architectural photographers for lighting interiors of large churches and cathedrals as well.

Painting with flash is best done with the camera mounted to a tripod so a long exposure time can be used. If your camera has a "T" shutter setting, use it, because it does not drain the batteries, and it gives you the flexibility you need to position the flash away

from the camera. As an alternative, set the shutter speed to "B," and use a locking cable release to keep it open for the length of the exposure. (However battery power is used in this setting.)

During the exposure, the flash is held in the hand and fired manually, changing the position of the flash head each time so that a different portion of the cave is lit. The great thing about this technique is that the flash does not have to be held rigid—indeed it may be more effective if it is moved. Use slow speed film so that the shutter can be kept open longer, and hence the flash can be fired more times. Use a fresh supply of batteries or a flash charger (see Tip 56) so the flash will recharge quickly.

Be prepared to try different exposure times and a variable number of flashes, especially when using slide film. Color negative film is more tolerant of a wide range of exposures. Note all the exposure information (aperture, number of flashes, etc.) as well as the flash-to-subject distance so you have basic data from which to work next time.

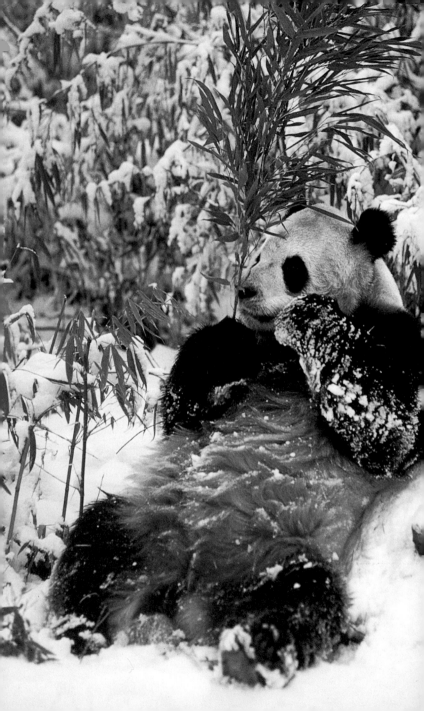

TIPS AND HINTS FOR EXTREME WEATHER

Wet Conditions

63 Bring a Brolly

Rain can bring a special magic to nature pictures that is all too rarely exploited. However, every care should be taken to protect all cameras from water. Even though some older mechanical models are more tolerant of getting wet than modern electronic cameras, they should nonetheless be wiped down after exposure to rain or snow as well. Even a small amount of water inside a lens—especially a zoom—can cause internal lens elements to fog, but a car heater (or a hair drier back at base camp) can rapidly clear the condensation from inside a lens.

On a trip to Japan some years ago, I spotted transparent plastic umbrellas for sale in a market. They were so cheap, I bought a couple. These umbrellas enable me to carry on working during rain or snow (providing it is not blowing horizontally!), and, unlike a waterproof rain cover (see Tip 64), they allow me to use a flash in these conditions. In severe weather I adopt a "belt-and-braces" strategy by using both an umbrella *and* a waterproof rain cover.

◀▥ While photographing a giant panda between snow showers in China, I covered the camera with a plastic shower cap and a towel to protect it from the elements. **(C)**

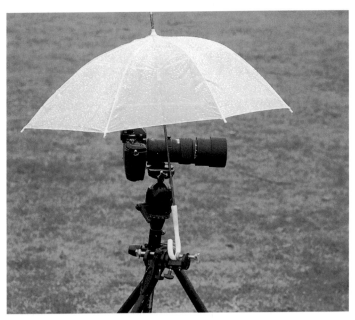

A transparent umbrella shields the camera from gentle rainfall without eliminating light.

There are times when I'm without an assistant that I envy an octopus. Take for example the scenario of using a brolly (umbrella) to protect a camera. Even when the camera is mounted on a tripod, it is difficult to focus manually, release the shutter, *and* hold the brolly. I have found a way to gain another arm by using a couple of Bogen/Manfrotto mini clamps linked together with a Bogen connecting stud. One clamp is fixed to the horizontal base of the Benbo quick-release lever while the other holds the brolly in place. A transparent umbrella has the advantage that it does not eliminate any light falling on the subject (or the camera).

Do not entertain the idea of fixing a brolly to a tripod on a windy day. While it probably won't result in the whole setup lifting off Mary Poppins style, it could easily crash to the ground.

Raincoats for Cameras

64

Working in rain or snow with modern electronic cameras is always hazardous, so I carry in my photo pack a small ultra-absorbent towel such as a Packtowl (available from camping supply stores), which wicks up surplus water. It can also be draped over the lens barrel and used to soak up falling rain or snow. This is fine for light showers or brief encounters with rain, especially when used in conjunction with an umbrella (see Tip 63). However, the only practical and safe solution in driving rain or a snowstorm is to use a completely waterproof, made-to-measure cover.

I use Cameramacs, made in Britain of black or green water-proof-backed nylon. They are custom-made for any specific combination of SLR camera and lens (you must quote the camera's make and model, focal length of lens, and maximum aperture when ordering). Other custom-made rain covers are the Laird Rain Hoods®, made in the U.S.

I have Cameramacs for my 80-200mm f/2.8, 300mm f/4, 200-400mm f/4, and 500mm f/4 Nikkor lenses, and my Nikon F4

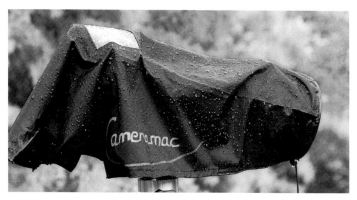

This made-to-measure Cameramac is a reliable waterproof cover for a 200-400mm zoom lens and camera.

cameras. Each cover fits over the camera and lens, is attached via the camera eyepiece, and is secured around the lens hood by means of a drawstring. Velcro strips and snaps are used to secure the open side beneath the lens barrel to prevent the cover from flapping in a strong wind. I have used the rain covers in torrential downpours and, although I was soaked, the camera remained dry! However, I do recommend when you are changing a roll of film, try to have someone hold an umbrella over the camera (see Tip 63).

I also make a point of collecting every elasticized shower cap I find supplied with bathroom accessories at hotels, so I can use one as an ephemeral protective cover for a camera against light, but persistent, rain. A shower cap fits snugly around the camera body and, what is more, doesn't flap in a breeze. Since it won't cover the lens, though, a small towel comes in handy.

It is also worth keeping a few different-sized plastic bags in your photo pack for use as makeshift covers for cameras with longer lenses. The bag needs to be large enough to completely enclose the camera body and much of the lens. A rubber band can be used to secure the open end of the bag around the lens barrel.

More robust rain covers made from transparent PVC are produced by EWA-Marine and are less likely to tear than either a shower cap or a plastic bag.

65 Cameras and Sea-water Don't Mix

Having written off a Hasselblad in the Seychelles when my tripod sank into a mangrove swamp, I know nothing is more fatal to camera equipment than seawater. After seeing a gentleman step ashore onto a steeply sloping beach in the Galapagos with a naked Nikon around his neck only to land face first in the sea, I learned to adopt a cautious attitude when working anywhere near seawater.

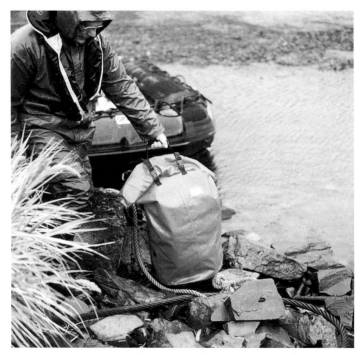

An REI Dry Gear Riverpack protects a photo pack from both salt spray and rain.

Before embarking on a boat trip (such as a motorized inflatable raft ride from ship to shore), it is a wise precaution to individually wrap each body and lens inside a plastic bag before stowing them in a photo pack. Then place the complete pack in an oversized REI Dry Gear Riverpack (complete with shoulder straps) so as to eliminate any risk of it becoming drenched with sea water. Riverpacks are available in various sizes from REI, which incidentally states in its catalogue that they are *not* recommended for carrying photo gear. But I use them as the first line of defense against seawater (or torrential rain) penetrating a padded photo pack. Indeed, in a remote location such as Antarctica, I dump the Riverpack with my life jacket above the high-tide level and use my photo pack so I can more easily move around on shore. Small photo packs can be protected using smaller, but equally tough, waterproof stuff sacks.

A rigid Pelican case with a sizable O-ring seal is also an excellent accessory for protecting gear from water, but I don't personally enjoy lugging a case over rough *terra firma*. I much prefer to wear a photo pack on my back so I can have both hands free.

HUMID CONDITIONS

 66 **Keep Film Dry**

Once film has been removed from its original airtight packaging, it should be kept as cool and dry as possible—especially after it has been exposed and before it is processed.

In a highly humid environment, molds can grow on both unexposed and exposed film emulsion. Films should, therefore, be packed in airtight containers with dry silica gel crystals contained within two-layered, finely woven cotton bags to prevent loose crystals from entering film cassettes and scratching the film. Indicator crystals are blue when dry and turn pale pink after they absorb moisture. To reuse the crystals, they need to be gently heated in an oven (or in a tin over an open fire) so that the blue color gradually reappears as the water evaporates.

In sub-zero temperatures like those I experienced while photographing ⟫ harp seal pups in Canada's Gulf of Saint Lawrence, you need special items to insulate your camera, lens, and tripod from the severe cold.

COLD CONDITIONS

67 | Leg Warmers

As Herbert G. Ponting discovered while working on Captain Scott's ill-fated 1910–11 British Antarctic Expedition, ultra-cold metal and bare flesh have a fatal attraction. When his tongue came into contact with a metal part of his camera, it froze to it instantly. He had no option but to jerk himself free and then gag his mouth with a handkerchief to quench the flow of blood from his tongue!

Even if you aren't in the Antarctic, carrying and handling a tripod with naked metal legs in sub-freezing temperatures is at best uncomfortable and at worst a liability.

The solution is to insulate the tripod's legs, which also helps to cushion its weight when carrying it over the shoulder. Ready-

made Tri-Pads are a brilliant solution to coping with frigid tripod legs. Each leg pad is made of an inner foam pipe strip with a black water-resistant nylon cover secured by Velcro. An optional alternative is to purchase one shorter pad (available for specific tripod makes and models) so that the tripod can still accommodate photo accessories that clamp onto the leg. When you are working on wet, muddy ground or sandy beaches, the nylon covers serve a dual purpose. After being removed from the tripod, all three covers can be connected via the Velcro strips to form a ground sheet on which to place lenses and accessories.

An alternative is to make your own padded covers by securing foam tubes slit lengthwise (like those used by plumbers to insulate water pipes) with waterproof tape. The only snag about this is if you use a Benbo tripod (which has the outer leg section at the base), the covers need to be removed each time the legs are immersed in water. The Velcro on the Tri-Pads not only makes for easier removal but also speedier assembly. Also, without the protective water-resistant nylon covers of the Tri-Pads, naked foam tubes can easily become damaged when working among jagged rocks or aa lava. For situations such as this, Gitzo makes elasticized sleeves that fit snugly over foam tubes, which protect them from damage by sharp rocks.

 ## 68 Lens Insulation

This tip I picked up when photographing cranes dancing on the snow-covered island of Hokkaido in Japan. There, in January and February, the temperatures plummet well below freezing. Being the sole western (and female) photographer at the site, I attracted much attention as I wandered among the Japanese photographers and surveyed their equipment. Several of them arrived with a pair of tripods—one for a 600mm and the other for an 800mm lens—plus camera cases loaded onto a sled (see Tip 71). Each lens sported a colored elasticized wrist band on the focusing ring,

A rubberized strip usually used to protect tennis racket frames also serves to insulate your focusing ring when working in cold weather.

which served both to insulate it from the severe cold (making handling more comfortable) and also to provide a better grip for focusing the lens manually.

Some time after I returned home I was in a sports shop where I spotted self-adhesive rubberized strips for protecting racket heads. I much prefer these because they can be cut to fit any lens, and they don't slip like the wrist bands, yet are easily removed.

Don't write off this inexpensive accessory for use with auto-focus (AF) lenses. Since batteries fail so easily in severe cold weather (see Tip 69), it makes sense to save battery juice by manually focusing when not taking action shots.

69 | Camera Coat

Extreme cold is death to batteries, therefore any electronic camera—regardless of the price tag—will be rendered useless if the batteries fail. Some more expensive cameras have a remote cold-weather battery pack that is connected to the camera via a cord so the pack can be kept warm inside a pocket or an anorak.

When I know temperatures are going to plummet below 14° F (–10° C), I use lithium Energizer® batteries, which are designed to be used down to –4° F (–20° C), *and* I insulate my Nikon F4 bodies with a homemade thermal jacket made from double-layered acrylic fleece. Before fixing the jacket to the camera, I tape a small chemical hand-warmer over the battery compartment, which keeps my camera functioning in temperatures as low as –22° F (–30° C)! The jacket is fastened with hook-and-loop (Velcro) strips so it can be removed—even with gloves—when the film needs changing.

For such a jacket to function efficiently, it needs to envelop the camera completely, including the bottom of the camera. Unfortunately, this covers the tripod mount. When a long lens is used, this is no problem, because the camera and lens are mounted to the tripod via the lens' tripod mount, leaving the camera's mount free to be covered with the jacket.

SNOWY CONDITIONS

 ## Snow Shoes for Tripods

It is surprising how a solution to a problem can be found in the most unexpected places. When I was first faced with the problem of how to prevent my tripod legs from sinking into deep snow, my thoughts turned to the baskets used on cross-country ski poles. However, living far from a ski supplier, I never managed to track them down.

Ever-mindful of the need to find an inexpensive way to help spread the weight of the tripod over the surface of the snow, I recently tracked down some molded plastic mini-ponds to put in our toad tanks. Each has a base measuring 3 inches (7.6 cm) square and a crater-like "pond," which perfectly cups the base of a Benbo tripod leg.

My mini-ponds are brown in color, so they show up well against the snow, and at a cost of 50 cents each they hardly break the bank. Each weighs a mere 0.4 oz. (11 g), and if the

One way to prevent tripod legs from sinking in snow is by using squares of plastic to spread the weight over the snow's surface. Photo: The Saunders Group.

cup is lined with plastic putty, can be temporarily fixed to a tripod leg.

Another solution is to cut 6 x 6 in. (15 x 15 cm) squares from the stiff, corrugated, plastic sheeting used to protect photographs in the mail. A small hole cut out of the center of each square stops the legs from slipping off the plastic.

71 | Go Sledding

Some years ago when I decided to join an expedition on a Russian icebreaker to photograph emperor penguins in Antarctica, I remembered my son's sled—long since stashed away in the back of our garage. I noticed a few raised eyebrows when I checked it with the rest of my baggage onto the Royal Air Force airplane to the Falkland Islands where I was to join the icebreaker. Without

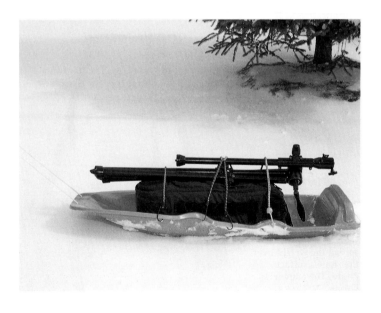

this sled I would never have been able to transport two camera systems—Nikon and Hasselblad—each complete with several lenses, plus my Benbo tripod, many miles over the Antarctic continent to reach the awesome emperor penguin rookeries. These have to be one of the world's natural wonders.

If you have to walk any distance across flattish ground covered with snow, it is worth investing in an inexpensive plastic child's sled for transporting your photo pack and tripod. It is sensible to take your gear to the store to ensure that the sled is wide enough to fit it all in the tray (try to get one with raised sides all-round). As a precaution, I strap everything in place with elasticized bungees. It may be necessary to replace a thin central pulling cord with ropes that are attached to each side to stop the sled from yawing side to side.

Towing a heavily laden sled over flattish ground is one thing, but take care when traveling on downhill gradients because it could so easily crash into you.

◄▥ **A sled can be used to tow photographic gear over snow or ice. Photo: The Saunders Group.**

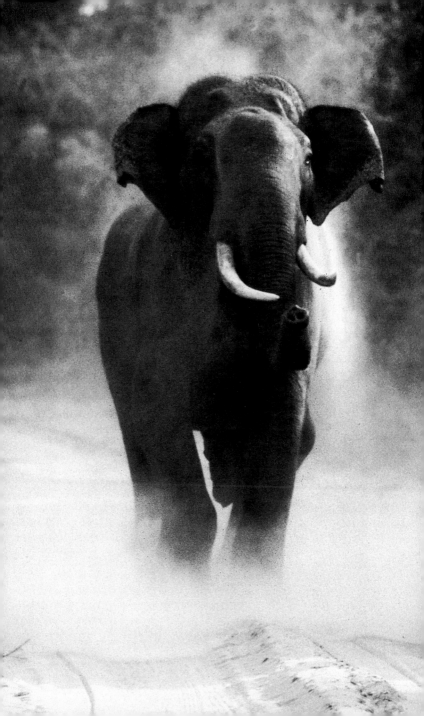

TIPS AND HINTS
FOR WILDLIFE

72 Camouflage Yourself

Lightweight, portable camouflage materials are invaluable for hiding yourself while photographing timid birds in situations where there is no natural or permanent blind or there isn't time to erect your own. Camouflage nets (scrim and leaf screen) can be purchased from army surplus and wildlife supply stores. Light in weight, they enable a photographer to blend in with the surroundings very effectively.

If several nets are joined together, they can be strung up as a temporary screen between trees. This is especially useful for photographing wetland birds nesting close to the water's edge. Even though the holes in the mesh aren't large enough initially to accommodate a lens hood of a fast long lens, once the camera is in position all you need to do is make a few snips in the mesh to enlarge the hole. A long lens can be disguised by covering it with tubular camouflage sleeving (see Tip 73).

It is quite impractical to belly crawl with a net over your body, but a portable camo cover such as a pocket blind or the N-visi/Bag photo blind is a neat solution. Both are made of camo material and cover a person complete with camera. A small opening allows the lens to poke through. These portable blinds

⬛ **Only by using a fast long lens and pushing my film one stop was I able to capture a bull elephant charging towards my jeep at the end of the day in Sri Lanka.**

can be used while you are lying, sitting, or standing and are fine so long as the temperature remains low, otherwise you may sweat, thus giving your location away. However you are camouflaged, when approaching acute-nosed mammals, remember it is more important to position yourself downwind (see Tip 73) than to be perfectly disguised visually.

73 | Stalking on Foot

My first encounter with muskoxen was during a trek in western Greenland, where I found they were remarkably approachable—providing I didn't confront them suddenly. In this treeless landscape I made a slow, careful stalk—from one boulder to another—as they grazed. As soon as one animal looked up, I froze. Working on my own, adopting an unhurried pace, I was able to get close enough for a single muskox to fill much of the width of a vertical frame using a 400mm lens. A local naturalist later told me a muskox can only charge in a straight line, so you must freeze when it begins to charge, and at the last moment step to one side. Fortunately, I never had to put this tip to the test!

When stalking animals on foot, it is vital that you be dressed comfortably in a way that blends in with the surroundings. Contrary to popular belief, camouflage clothing is not recommended when working in Africa since it is standard army uniform in many countries and therefore illegal for civilian wear.

Any shiny parts of cameras and camera supports should be covered with self-adhesive camouflage tape when working in locations where green or brown vegetation dominates. Lenses—especially if they are white—can be disguised by slipping elastic camouflage sleeving over them (like the white tubular bandages used for supporting strained wrists or ankles). (See "Wildlife Watching Supplies" in *Resources*.) Indeed, the white bandages can be used to disguise black lenses when working on white sandy beaches or in polar regions.

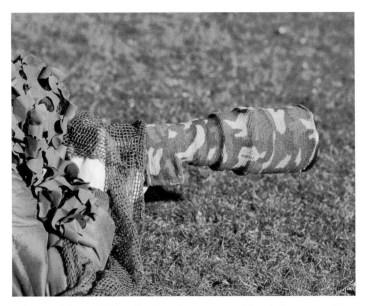

When stalking wildlife, disguise the camera with tubular camouflage sleeving and your hands and face with camouflage netting.

Whether you are camouflaged or not, animals will react to sudden movement, especially if you make an approach in a straight line. However, if you move by zig-zagging from one tree or rock to another when the animal has its head down to feed, you are more likely to gain closer access.

Mammals in general have an acute sense of smell, so it is essential that they be approached upwind so they won't detect your scent and bolt suddenly. If a grazing animal looks up repeatedly and appears nervous, resist the temptation to take any pictures until it settles down. Should the noise of the shutter and the motor drive make it even more wary, to avoid undue stress to the animal and maybe any risk to your own safety your best course of action is to retreat.

The success of a stalking approach not only varies from species to species, but also from one individual to another; however, you will soon be able to judge how close you can approach safely without causing the animal to adopt a defensive stance or take evasive action.

74 | A Mobile Blind

Although a permanent blind overlooking a wetland area rich in birds or an African water hole in the dry season will provide plenty of scope for photography, the camera angles will inevitably be limited. A vehicle, on the other hand, provides much greater flexibility for gaining speedy access to a larger area of ground than is possible on foot as well as a choice of camera angle relative to the sun. Indeed, when in carnivore country—whether you are among lions in Africa or polar bears in Canada—shooting from a vehicle is the only prudent way to work if you want to be sure of seeing the pictures you take (contrary to the belief of a lady I met at Cape Churchill who expressed

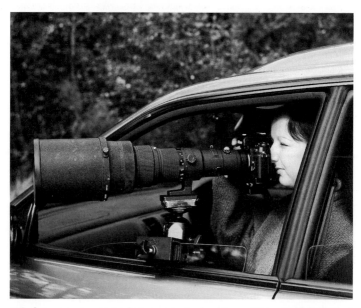

Window mounts are made to support a long lens when a vehicle is used as a blind.

great disappointment at not being allowed to stroll among the polar bears)!

Generally, using a tripod inside a vehicle is completely impractical both from the space and time points of view (although I have used the versatile Benbo when working on my own). But even when sharing a van on safari with other people, compact camera supports such as a beanbag (see Tip 17) or a window mount (see Tip 18) are invaluable for steadying long, fast lenses—providing the engine is switched off and no one else moves around just as you are about to shoot.

Agreeing beforehand on a working strategy with other people pays dividends, as does briefing the driver when you are not driving yourself. If you are lucky enough to have a driver who has worked with a film crew, he or she will understand about light and probably maneuver the vehicle into the best possible position. Most drivers, however, need education and guidance as to where to position the vehicle *before* they switch off the engine.

A jeep has a dual advantage over a car: It can provide access across the most inhospitable terrain, and it has a higher viewpoint. Nonetheless, I have used a car to work in drive-through reserves in many countries as well as on minor roads meandering around tidal inlets in Scotland and Ireland where herons frequently hang around.

Always respect local regulations, such as not feeding wild animals, since once they become habituated to being fed from vehicles, they will either be a nuisance or, worse still, a danger to future visitors. I have experienced baboons and vervet monkeys leaping onto car hoods and attempting to enter open windows, while an elephant in Uganda, displeased at not being fed, actually turned a car over to find food.

75 | No More Bad Vibes

Long lenses can produce punchy pictures, but only if the subject, or some part of it, appears sharp. As lens length increases, so does the problem of vibration caused by the mirror flipping up, resulting in unsharp pictures if taken at slow shutter speeds.

Fixing a long lens to a tripod won't in itself ensure that all pictures are pin sharp. Even when a tripod collar on the lens enables the lens and camera to be supported at its center of gravity, vibration can still occur. The type of tripod you use makes a huge difference. A wobbly one is more of a liability than an asset. There are several points that need to be considered when buying a tripod for use with a long lens. For starters, the legs need to spread out well to form a firm base. Ideally, the distance between the base of any two legs when fully stretched out should exceed the length of the lens. In addition, a tripod will provide much greater stability if the center column is not raised. This means that the legs alone need to provide enough height for the camera's viewfinder to reach your eye when you are standing.

For cameras without a mirror lock or in situations when it is impractical to use this facility (because you need to follow the subject's motion or view its expression up to the moment the shutter is released), there are a few other techniques that will help to dampen vibrations. Rest a hand (or a beanbag—see Tip 17) on top of the lens directly

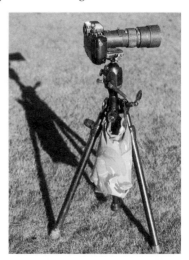

Use a beanbag to add ballast to a tripod and lower its center of gravity.

above the tripod head to quell any vibration passing along the lens barrel. Hanging a weight beneath the center of the tripod will also help increase stability. If you have a tripod with a relatively short center column, screw a hook into the base to provide a convenient weight hanger.

76 Expressions with Impact

Some photographers are batty about birds, dashing off to exotic locations so as to notch up yet more species on film. While I freely admit to having a passion for penguins, there is a limit to the repertoire of their head postures: Head up, head down, bill open, closed, or tucked in beneath a flipper. Mammals, on the other hand, win hands-down for the range of facial portraits they present to a photographer. Amusing expressions of animals captured on film will always have a ready market, whether it be the tabloid press, children's magazines, or greetings cards.

The pliable skin around the lips and cheeks of primates in particular, together with movements of eyes, eyelids, eyebrows, or ears, offer wonderful scope for capturing a whole gamut of facial expressions depicting various moods from pleasure and surprise to fear and aggression. Indeed, research primatologists often use photographs to memorize facial markings so they can identify individuals. Staying put in one place for several hours—even days—will reap rich rewards when you can begin to anticipate the reactions of different individuals within a family or communal unit by knowing which ones are dominant over others.

The range of animals in zoos and wildlife parks greatly increase the possibilities for capturing facial expressions on film. Indeed, taking time to observe the daily behavioral pattern of a particular animal—when it is fed, when it sleeps, and when it plays—will ensure you can anticipate the time when it is most likely to be active. Once I missed a great photo opportunity on my first visit to Trivandrum Zoo in India because long shadows

were cast across a hippopotamus enclosure late one afternoon. As the keeper appeared with a mound of grass, the hippo automatically responded by opening up its jaws into a cavernous gape. A quick word with the keeper revealed that the enclosure would be uniformly lit by the sun in the morning. So I came back, and true to form, the hippo reacted in a predictable way, and I got the shots I wanted.

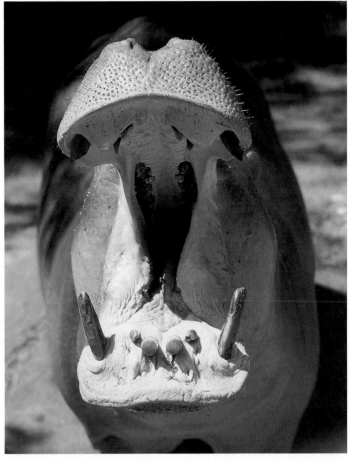

It just takes patience and a little planning to get a winning expression. (C)

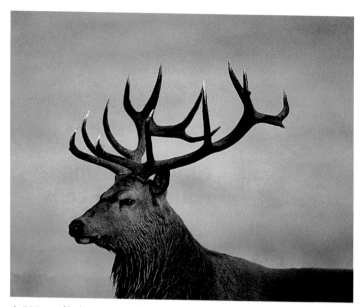

A 500mm f/4 lens was used to make this red deer stag "pop" from the foxy-colored bracken lit by early morning sun.

77 The Best Portrait Lens

Gaining reasonable depth of field by stopping down the lens (see Tip 93) is usually an important criterion in close-up photography, unless you want to achieve an abstract soft-focus image. However when shooting wildlife portraits, the converse is true. Birds and mammals look most impressive when they are isolated from an indistinct (or defocused) background.

Pro wildlife photographers who lug heavy, "fast" lenses around aren't just being macho; they need huge front elements to gain a wider aperture and hence a shallower depth of field. In addition to making the subject "pop" from the background, a fast

lens lets in more light, which makes it easier to focus in poor light *and* allows a faster shutter speed to be used.

Apart from the cost and the weight of these lenses, the downside of using them is that there is little room for error in focusing. The subject's eye(s) at least must be in focus, as nothing looks more lifeless than an animal with an unsharp eye.

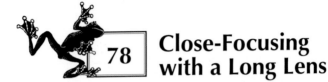

78 | Close-Focusing with a Long Lens

When buying a long lens, in addition to deciding on the maximum aperture (see Tip 77), you should also consider how close it will focus. Long lenses are not just useful for bringing wary subjects in closer visually, they can also highlight individual facets located within a broad vista. In addition, they can provide you with impressive portraits of birds on their nests (when working from a blind) or frame-filling pictures of flowers, fruits, and cones on trees (see Tip 91).

When working away from home—especially when trekking—I have to limit the number of lenses I carry. An inexpensive way of reducing the minimum focusing distance of the lenses I do take is to insert a small extension ring between the lens and the camera body. Even when I am without my 200mm macro lens, by using a 14mm extension ring with a 180mm lens, I can still obtain frame-filling pictures of frogs in a pond or lizards basking on a rock. The closest this lens will normally focus is 6 feet (1.8 m), but with the 14mm ring it will focus down to 4 feet (1.2 m).

Many a time this lightweight accessory used with a 300mm lens has enabled me to crop tightly onto groups of butterflies drinking from a wet patch. When a small extension ring such as the 14mm is used, the light loss is negligible, but in any case, a camera with TTL metering will automatically compensate.

A 27.5mm extension ring was used with a 300mm lens to capture this frame-filling picture of ponderosa pine cones.

79 | The Bait Debate

Using bait to entice wild animals to move in closer to the camera is a technique that should be used with caution. Putting food (and water) out for garden birds is one thing, but when done in an open, remote location, this strategy may result in attracting hawk-eyed predators in search of easy prey.

The advantage of baiting in a garden or on any private property is that you are able to work from a blind—perhaps even using the house or a shed—free from interruption, whereas a blind erected on public land immediately pinpoints something worth photographing and attracts people like bees to a honey pot.

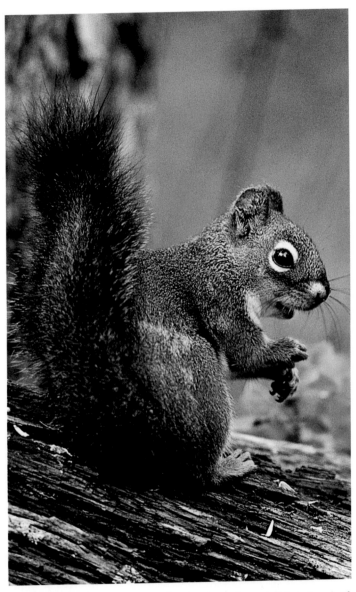

Lured to this log by nuts wedged into a piece of wood, this red squirrel was photographed from inside a house through an open window.

Popular picnic spots and campsites are a Mecca for opportunistic birds (as well as chipmunks and squirrels) and are always worth checking out to see if there is anything you haven't already photographed.

Elsewhere, the rewards of baiting will be reaped more quickly in the winter when natural food is sparse. In frigid weather, fresh supplies of water will attract birds to drink, whereas in summer, a natural, wet, muddy patch will attract house martins and swallows gathering mud for their nests.

Before laying any bait, check out the camera angles to make sure the background is unobtrusive (without hot spots from patches of white sky, signs of civilization, or branches cutting across behind where the animals are likely to feed). Also check to see that shadows won't be cast across the feeding area at a crucial time. Large potted green (never yellow!) conifers can make useful portable, naturalistic, out-of-focus backgrounds for garden birds.

Select food that is most appropriate for the animals you want to entice. This means nuts for squirrels, grain for seed-eating birds and road kill for carrion-eaters. Avoid at all costs large hunks of bread and any other unnatural or unphotogenic food. To ensure that squirrels or birds will stay within view of the camera for as long as possible, wedge nuts into crevices of an old tree trunk, on the side opposite the camera. If grain is mixed with peanut butter or suet, this can also be pushed into cracks. Road kill, on the other hand, will need to be unobtrusively pegged down to prevent a powerful bird from swooping down and flying off with the bait. Animals meet their death more frequently on busy roads, where it is impractical to work; but if the corpse can be safely collected and transferred to a remote area adjacent to a rarely used road, you can use the car as a mobile blind.

Even when traveling by boat, you can take advantage of seabirds that are following a ship, as they watch for food being churned up in the wake or scraps being thrown overboard from the galley.

Feeding wild animals should never be done without considering the consequences (see Tip 74). Some animals can be dangerous; for example, once monkeys learn to associate humans with food, they will pester them until they get fed. If no food is forthcoming, they may bite, and some carry a fatal encephalitis.

80 Keep Your Distance

We have all seen them: pictures of hares or grazing animals staring wide-eyed into the camera with their ears laid back. These are not "scoop" pictures, but rather evidence of quarry that is obviously very ill-at-ease with a photographer who has moved in too close. This is done either out of ignorance, an overpowering desire to get something different, or not possessing a long enough lens to stand farther back. Yet who benefits from such a close encounter? Certainly not the animal, and neither does the photographer's reputation. If you adopt a philosophy that the welfare of a wild bird or mammal is more important than getting the picture, you will gain respect from other *bona fide* wildlife photographers.

I would argue that there are always opportunities to work at close quarters and use a shorter lens with animals that have either become habituated to man or are captive-bred. But when these animals are photographed, the pictures should be clearly marked that the animals are not wild and free.

81 Working from Boats

What can be more idyllic than paddling a canoe through flat, calm water that mirrors its surroundings to gain a close encounter with a heron, a water vole, or a lily trotter? For longer sojourns (maybe when working a nest with eggs or young chicks), a camouflage net draped over wire or bamboo cane hoops on a canoe or boat will help to disrupt the boat's outline so that the odds of being detected are reduced.

Whenever I am abroad and have just half a day to spare, I never miss the opportunity to take a boat trip, preferably one

These pintado petrels were taken from on board a ship en route to Antarctica, using a monopod to support a camera with a long lens.

I have chartered myself. Then I can brief the boatman about my hand signals (notably, ensuring the engine is cut before we reach the objective so we can quietly drift into position). Boats are essential for close encounters with whales and dolphins, and they are useful for offshore views of seabird colonies or sea lion haul-outs.

Working from a boat requires a totally different strategy from working on land. Unless you plan to work from a boat anchored in relatively calm water, tripods are out, although a monopod or a shoulder pod (see Tip 83) can ease the strain of handholding a camera with a hefty lens for long periods.

Attempting to photograph seabirds in flight from a boat in rough seas is anything but idyllic, and being a rotten sailor, I never last long on deck. Yet, in calmer weather, I soon become mesmerized by the grace and agility of petrels as they suddenly swoop towards the ocean only to rise above the next wave—sheer poetry in motion. The best monopod for working on boats out at sea is a Monostat with a swivel Toe Stabilizer base from Photographica. This ball-jointed foot enables the camera to be steadied even when the pod is used at an angle of up to 30° from the vertical.

TIPS AND HINTS
FOR ACTION SHOTS

| 82 | | **Use an OutPack ScopePACK** |

Carrying a ready-to-use camera with a long, heavy lens mounted on a tripod is always risky over rough terrain, yet unrepeatable shots can be lost in the time it takes to unpack both camera and lens from a conventional photo pack, connect them, and make sure they are firmly attached to a tripod.

Every keen birder has the same problem with a spotting scope, so it's no surprise that it was a birder who designed this unique pack to carry a scope ready-mounted on a tripod. Imagine a lightweight, foam-padded, tubular 2-foot-tall backpack, complete with a padded, adjustable harness and waist belt that allows a telephoto lens, up to an 800mm,

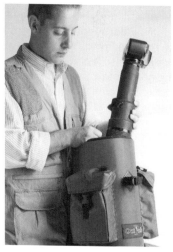

An OutPack ScopePACK lets you carry a camera with a long lens safely, and it's ready to shoot in an instant. Photo: The Saunders Group.

◀ **A heavy snowfall creates a background of striking contrast for a leaping cougar. (C)**

to be carried ready-mounted on a camera. The OutPack Scope-PACK has two alternative tops—a flat padded camera hood and a cone-shaped HiTop™ that adds another 14 inches to accommodate taller scope and tripod combinations. A couple of lash tabs conveniently secure a monopod or an umbrella to it (see Tip 63), while four exterior pockets provide ample room for other camera bodies, shorter lenses, flash units, filters, film, and even lunch.

83 Shoot from the Shoulder

When stalking wildlife, forget about taking along a tripod. It is both cumbersome and impractical to set one up without the risk of disturbing your quarry. Carrying your gear at the ready so that your mobility is unimpaired is the key to successful stalking, yet a long lens still needs to be supported in some way. Aside from bracing your body (see Tip 16), the solution is to use either a monopod or gunstock (also known as a shoulder pod).

Shoulder supports come in a variety of shapes and are made of many different materials (wood, metal, and plastic, to name but a few), so it is essential that you try a few out before purchasing one. I know this from experience, because several I have tried certainly weren't designed to fit my body! They should fit comfortably around the arm and body junction and preferably up and over part of the shoulder as well. The hand grip should feel comfortable when the support is pressed tightly against your body. An integral cable release needs to be positioned so it can be tripped by the index finger of the hand holding the support. This frees your other hand to push branches to one side and, if necessary, manually focus the lens.

Leonard Rue Enterprises produce two wooden gunstocks with an electronic release bracket as an option. It may also be worth checking out supports for video cameras, as they tend to have a more substantial up-and-over-the-shoulder support than some of the less-expensive shoulder pods designed for still cameras.

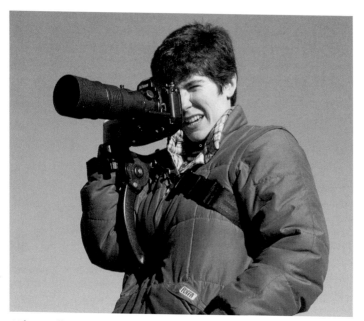

When stalking with a camera, a video camera support provides steadiness and portability.

84 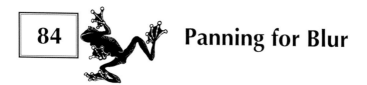 Panning for Blur

Resist the instinct to persistently use a fast shutter speed to freeze action. Experiment by using slower speeds to create an impression of movement. A creative approach for depicting a bird in flight or a mammal running across the field of view without using flash is to blur the background by moving the camera to follow the motion of the subject. Known as panning, this technique is popular with race car photographers, who have the advantage of shooting subjects that repeatedly travel the same route at a fixed distance from the camera.

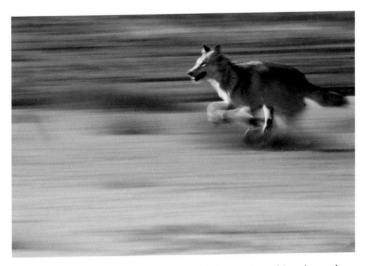

By panning the camera in the same direction as the subject is moving, the background becomes streaked, creating an impression of motion and speed.

In theory, the technique is quite simple, but it takes a bit of practice to perfect. Since a shutter speed of at least 1/15 or 1/30 second is required, a slow speed film is essential. It is easier to follow a subject's motion if the camera is mounted on a shoulder pod or gunstock (see Tip 83) rather than simply held in the hand. Anyone who is adept at bracing their body to counteract the risk of camera shake while handholding a camera with a long lens will find that they instinctively freeze the camera fractionally before the shutter is released. In fact, for optimum effect, against all natural instincts, you need to pan at an even speed before, during, and after the shutter is released. An excellent practice exercise is to set up along an open stretch of road and pan the camera on cars as they pass.

In situations when a number of animals are following behind one another on a level track, it is possible to pan the camera mounted on a tripod in the same way as a film camera operator would. A pan-and-tilt head with a long handle makes for easy panning, although I invariably use whatever large monoball head happens to be on my tripod. It is worth forgoing a couple of shots

to first check that the tripod head is level (or else adjust the angle of a long lens by rotating it within the lens collar) so that the camera angle remains on line with the track. Otherwise the position of the animals in the frame will vary throughout the length of the pan.

In a panned picture, horizontal elements of the motion (such as the animal's body) will appear reasonably sharp, whereas any vertical elements (such as running feet and legs, or flapping ears, tail, or wings) will appear blurred. This is not a disadvantage; indeed it can serve to aid in conveying the impression of motion. A bonus factor achieved by panning is that background objects are no longer obviously discernible because they are transformed into fluid streaks.

When working in changeable light conditions, use shutter-priority mode to maintain a constant shutter speed. In this way, the camera's meter will not automatically set a speed that it is too fast to produce the effect you are after.

Aiming to deliberately create a blurred image of an animal in motion is always something of a gamble, since you cannot see the effect until the picture is developed. But this is the very reason why—when it succeeds—such a creative approach to wildlife photography can be very rewarding.

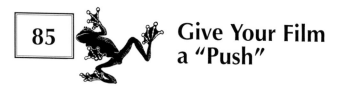

85 Give Your Film a "Push"

At the first and last light of the day or in a dark forest, the ambient light may not be sufficient to set a fast enough shutter speed to prevent subject blur of moving animals. In some situations, this can be an advantage if either slow-sync flash (see Tip 53) or panning (see Tip 84) is possible. But if you don't have fast film, and the animal is not moving across the ground or through the air, or there doesn't happen to be a clear view to pan or use fill flash, there is another solution.

Slide or transparency film (process E-6) can be "pushed" to a higher speed than the ISO rating given on the film cassette. While

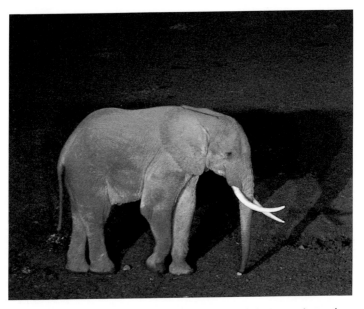

One of the attractions at Aberdare National Park in Kenya is to view spotlit game as they travel to a salt lick. My normal film (ISO 100) proved too slow, but I was able to purchase a roll of ISO 400 film, and by pushing it one stop to ISO 800 and opening my lens all the way, I gained enough speed to take a sharp photo of a moving elephant.

this can be done in 1/3-stop increments, in poor light it obviously isn't worth altering the speed by less than 1 full stop. Kodachrome 200 is designed to be pushed either from ISO 200 to 500 (1-1/3 stops) or 200 to 800 (2 stops). This has enabled me to take pictures that otherwise would not have been worth keeping. For example, a giant panda sitting down to feed on bamboo cannot be panned, yet its paws and jaws are constantly moving. My decision to expose several rolls at ISO 500 coupled with fill flash paid off, since these pictures have been used countless times— including on several front covers.

If I'm going to be taking pictures of animals moving at dusk or dawn, I opt for using the ultra-fast slide films that are nominally rated at ISO 800 but are designed to be "pushed" to ISO 1600 or even ISO 3200.

Once the decision to push a film has been made, you must stick with the altered speed for the entire roll. Either change the

film speed dial or set the exposure compensation dial to underexpose the film by the number of stops desired. Make sure to mark the film cassette with either an alcohol-based felt pen or a self-adhesive sticker, and tell the processing lab it has been pushed (there may be a supplemental charge).

There is a downside to pushing—the contrast is increased, and the granularity of the film emulsion becomes more apparent, so it is something that should be done sparingly when there are no other options available for taking a usable picture.

86 Take Sequences

Action in nature—an animal catching its prey, a toad hopping, a bird in flight, or a whale fluking in the sea—provides plenty of opportunities for taking a sequence of pictures. In addition to movement, certain aspects of behavior lend themselves to a photo sequence, particularly when a bird or mammal remains in a restricted area. Examples include places where animals are attracted to food or water, areas where social groups gather, or nests of birds. When a bird or mammal joins its mate there may be an opportunity to take pictures showing them greeting each other and engaging in mutual preening.

For a sequence to succeed, it should consist of at least three frames that together depict a progression and portray more information than a single exposure could. Before taking the first exposure of any sequence, ensure the subject is not tightly cropped within the frame so that there will be no risk of accidentally cropping extremities—such as outstretched wing tips or extended legs and tail—when the action begins. Varying the focal length with a zoom lens is not recommended, because this will introduce a variable parameter by changing the magnification of the subject. Try to shoot when the light remains constant, otherwise—even when an autoexposure mode is used—the series will look patchy because the aperture or shutter speed will change with the light level.

Fast action, such as a hummingbird hovering, requires high-speed flash to freeze the motion, whereas a bird flying or a mammal running across the field of view can be captured using a continuous motor drive coupled with a fast shutter speed. When shooting rapid motion, check that there are plenty of exposures left in the camera before commencing a sequence.

There are slightly longer-term changes that take place over a matter of hours (a flower opening) or days (chicks developing in a nest). In such situations where the subject maintains its position, the camera should remain fixed, but it needs to be protected against the elements or set up in a waterproof blind (see Tip 35).

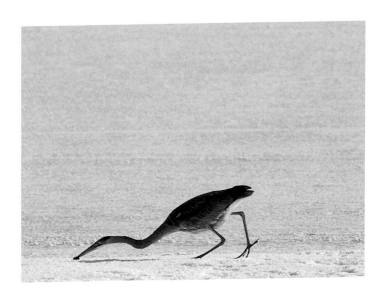

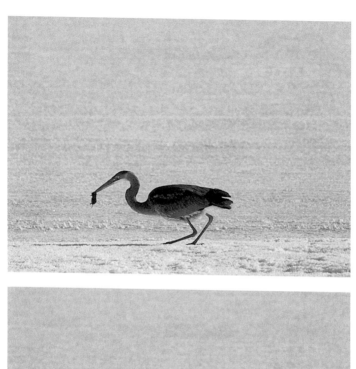

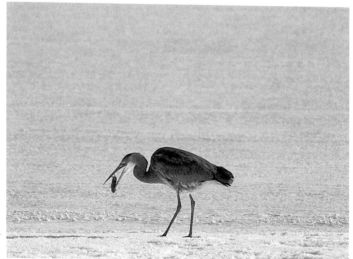

Using a car as a blind, I took this sequence of a great blue heron catching a vole at Lower Klamath National Wildlife Refuge in California.

TIPS AND HINTS
FOR PLANTS

87 Do a Background Check

After you have spent hours trekking in search of a rare plant, it is all too easy to be so elated at achieving your goal that you spend too little time considering the best viewpoint. No matter whether a plant is commonplace or rare, it pays to invest time in appraising the background.

If your camera has a depth-of-field preview button, use it to check that there are no distracting objects competing for attention with the plant. The background can, if necessary, be defocused by opening up the lens aperture so as to decrease the depth of field. Use a low camera angle for tall-stemmed plants to isolate their flowers against the sky and a high angle for marginal aquatic plants to isolate them against water. But one of the most dramatic ways of separating plants with inconspicuous flowers (notably grasses) from their surroundings is to take them spotlit by sun against a background in shadow. This approach can also be applied with equal success to small plants by using a person (or a camera bag) to cast a shadow behind a sunlit (or flashlit) plant. A dark backdrop induced by a shadow is more acceptable than either a piece of cardboard sprayed with black paint or the black side of a reflector propped up behind a plant. The former looks too stark, while creases in the latter are invariably visible in the photo.

◄▥ I used the camera's depth-of-field preview button to determine the optimum aperture for taking this sharply focused picture of a pickerel weed flower with a softly blurred background.

88 Steady Wobbly Stems

Plants may be fixed subjects, but they are far from stationary. They have a tendency to sway in the slightest breeze. When you are taking close-ups in poor light, this presents a major problem; but with the aid of a simple gadget, persistently swaying tall-stemmed flowers can be tamed. The solution is to shift the fulcrum from ground level to just below the base of the flower using a plant clamp.

All you need for this are a couple of split canes (sold in garden stores) or 15-inch-long (38 cm) metallic knitting needles,

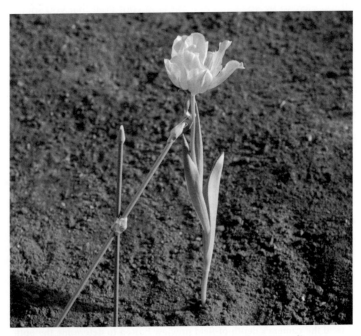

A plant clamp made from two knitting needles and a paper clip supports this tulip on a windy day.

some modeling clay or adhesive putty, and a metal paper clip. One cane (or knitting needle) is pushed vertically into the ground 3 to 4 inches (7 to 10 cm) to one side of the plant; the other is fixed to it at an angle about one-third to halfway up using the modeling clay. Since the angle is determined by the length of the plant stem, it will need to be fine-tuned each time. Open out one end of the paper clip into a hook and fix its other end with modeling clay to the end of the second needle. Gently hook the paper clip around the plant stem just outside the field of view. Even if wind begins to blow the flower, it will steady itself much more quickly when a plant clamp is used.

89 Make a Wind Shield

While a plant clamp (see Tip 88) is a great help when taking close-ups of one or more flowers on a single stem, it is impractical for steadying a clump of flowers. Wind can, however, be reduced by placing a clear Plexiglas™ wind shield around plants.

You may wish to design your own wind shield, but I use one made from four pieces of 3 mm thick Plexiglas cut to size by a hardware store. The advantage to using clear Plexiglas is that the natural background remains visible behind the plant and there is no loss of light. The 12 x 12-inch (30 cm x 30 cm) top piece is attached to three trapezoidal shapes each measuring 12 in. (top) x 12 in. (sides) x 20 in. (50 cm) (bottom). I use "invisible" cellophane tape to join the seams rather than permanent contact cement, since tape can be removed in order to transport the sheets flat. To prevent them from being scratched during transport, you can wrap each sheet in a piece of paper.

Place the wind shield on the ground with the open side towards the camera. The back wall, in particular, must be clean and free of scratches or other blemishes. Before taking a picture, check that the joints fall outside of the field of view and that the base of the back wall is completely hidden by leaves or grass.

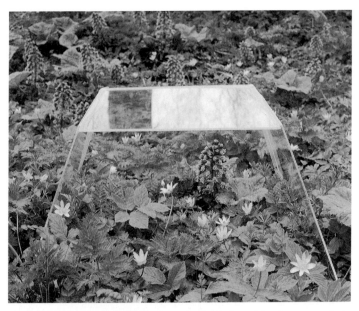

A clear Plexiglas wind shield prevents plants from blowing on a windy day, yet retains a view of the surrounding habitat. The dark strip on top of the shield is the reflection of a tree trunk.

Any short-stemmed plants to be photographed from above can be protected from wind by enclosing the entire working area within a light tent that has an overhead window. I either adapt my Plexiglas wind shield by removing the top and adding a fourth side, or else I use a truncated cone made from one of the thicker varieties of Rosco diffusion gel and five metal coat hangers for frame support. One hanger is opened out to make an 11-inch diameter circle for the top, and two hangers are joined together to make a 20-inch diameter circle for the bottom. The two remaining hangers are each opened out into a straight line and used to connect the top and bottom circles. The sides are then covered with a layer of Rosco diffusion gel (or dressmakers' interfacing), using staples to secure it to the frame, and the base is weighted with coins or anglers' weights. This accessory doubles as both a wind shield and a light tent.

90 Kneel in Comfort

When using a low camera angle to take flowers, fungi, ferns, or mosses, you have no alternative but to get down on your knees. On damp and muddy terrain I use a thick plastic sack scrounged from an agricultural merchant to prevent me from getting soggy knees (these are stronger than plastic garbage bags and therefore are more resistant to being punctured by sharp stones).

The 60 x 26-inch waterproof Macro Ground Cloth produced by A. Laird Photo Accessories has the added advantage that it is large enough to protect your equipment as well as your knees. What's more, it rolls up into a small enough bundle (secured by Velcro) to fit in a photo vest pocket.

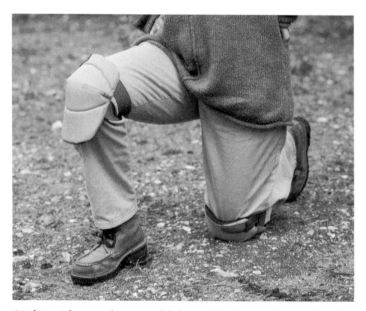

Gardeners' knee pads are useful for cushioning your knees from the hard ground.

While a Domke protective wrap (available in three sizes—11 x 11 in., 15 x 15 in., and 19 x 19 in.) is designed for cushioning a lens from knocks, it can double as a water-resistant ground cloth in an emergency. However, I wouldn't want to risk wrapping it back around a lens until it had been washed.

But when working on hard, dry terrain—especially rocks or lava—there is nothing to beat gardeners' knee pads for cushioning the effect of sharp points on the knees. I use a pair with adjustable straps secured by hook-and-loop strips (Velcro).

91 Bring Plants Closer

Don't use your long telephoto lenses just for birds and mammals; make them work for their money. When viewed with a long telephoto lens, inaccessible plants—such as trees growing on the far side of a canyon or across the other side of a lake—no longer appear as minute specks within a broad landscape canvas, but are transformed into intriguing cameos.

If I am stuck in a wetland area without a boat, I don't hesitate to use a long lens for bringing unapproachable water lilies in close. The flowers, cones, or fruits of a mature tree are invariably positioned high off the ground, so a long lens can help to increase the impact of these high-rise subjects. However, it may be necessary to use a short extension tube to reduce the minimum focusing distance of a long lens when taking a flower or fruit growing partway up a tree (see Tip 78).

Indeed, the advantage of using longer lenses is that only a slight change of viewpoint is sufficient to achieve vastly different

A 200-400mm zoom lens was used to get a frame-filling picture of these ▥▶
backlit teasel plants.

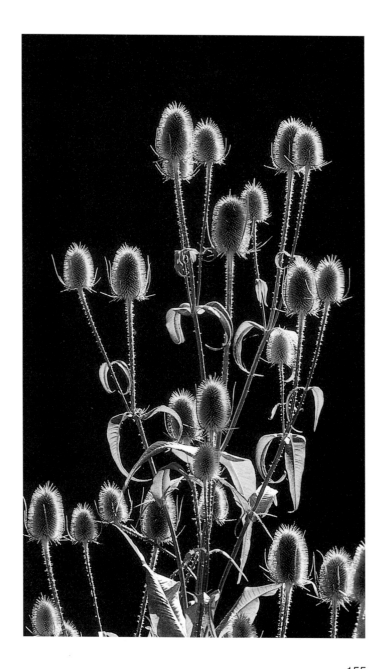

compositions. Leaf mosaics of trees viewed against the sky benefit from the use of a long lens for a tight crop. Even greater flexibility in framing a subject (e.g., a forest with a kaleidoscope of colors on a hillside in fall) is possible with a long zoom, such as my favorite 200-400mm Nikkor.

92 True Blue

Some blue flowers are difficult to reproduce on color slide film exactly as we see them. The gorgeous true blue of a morning glory invariably turns out mauve, because this flower reflects far-red and infrared wavelengths as well as blue. We cannot see these wavelengths, so the flower appears blue to us. All those color slide (transparency) films that are sensitive to the far-red and infrared wavelengths tend to produce mauve, or pinkish-blue flowers—especially on a sunny day.

Some years ago I ran a lengthy test shooting bluebells (which bring an azure sea to many British woodlands in spring) on a variety of different color slide films under different lighting conditions. I discovered that blueness can be enhanced by shooting on an overcast day or selecting plants growing in shade instead of sun. Also, a pale-blue 20 Color Compensating (CC) gel filter will enhance the blue for a frame-filling close-up, but will also give a blue cast to green stems and leaves or any other object in a wider shot.

As film manufacturers constantly strive to improve on film emulsions, it is difficult to recommend a particular film without the risk that it will be discontinued within a few months. One way of checking whether a transparency film is likely to reproduce true blues is to look at a graph that shows the film's sensitivity to the different wavelengths of light. If this curve drops off markedly at the end of the visible spectrum before the far-red and infrared bands, it is considered a "short-red" film, which does not record mauve and therefore should record blue flowers authentically.

There really is no shortcut to testing several types of film in order to make a direct comparison of the results side by side on a light box. I would suggest shooting a few frames of a blue flower at the end of one roll in sunlight and in the shade, both with and without a blue CC filter. Then reload and repeat the process at the beginning of another roll of a different type.

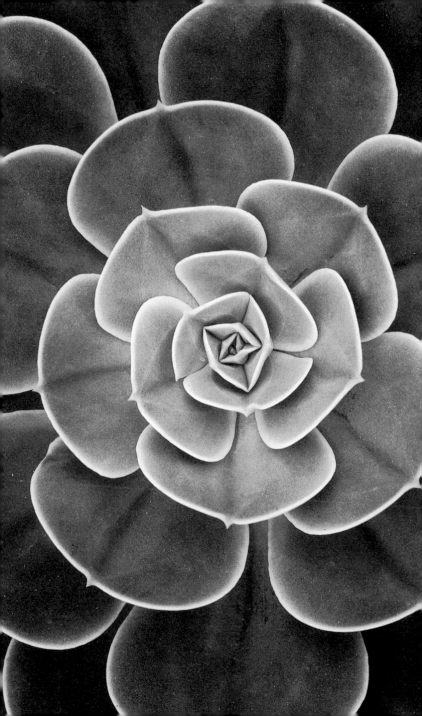

TIPS AND HINTS
FOR CLOSE-UPS

93 | Depth of Field and Close-Ups

Understanding depth of field and how to use it is basic to all photography (see Tip 29), but never is it more important than when taking close-ups. The choice of which combination of shutter speed and aperture to use for a close-up must, to a large extent, be governed by the depth of field required. Since this is a function of both the aperture and the image magnification, it can be increased by stopping down the lens, decreasing the size of the image within the frame, or both. Conversely, it is decreased by opening up the lens or by increasing the image magnification. Close-up pictures of the natural world that are used to inform need to be sharp, utilizing the maximum depth of field, whereas striking artistic images can be achieved by shooting with the lens wide open so that the depth of field is minimal.

Maximum depth of field for macro shots of plants growing flush with the ground, such as moss or a carpet-forming alpine, can be gained by positioning the film plane (i.e., the back of the camera) parallel to the ground. With close-ups, the depth of field increases equally on either side of the plane of focus. Therefore, focusing on the nearest part of a flower and stopping down the lens to, say, f/11 will bring into focus parts of the flower behind the plane of focus as well as an area in front of it—i.e., air—

◄ An overhead macro shot of this succulent reveals the spiral arrangement of the leaves.

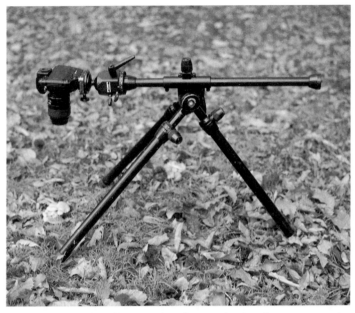

When photographing low-growing plants, orienting the camera so the film plane is parallel with the ground helps maximize the depth of field.

which is a waste of the potential depth of field! If you stick with the same aperture, greater depth of field will be gained by focusing slightly beyond the front of the subject.

I wouldn't even contemplate taking close-ups with a camera that doesn't have a depth-of-field preview button. Unfortunately, manufacturers of some modern cameras have dispensed with this function, which is invaluable for checking which parts of the subject are in focus at any aperture. If you want a flower to stand out from a confusion of stems and leaves in the background, you may need to open up the lens aperture from say, f/16 to f/8. The farther away the background is from the subject, the more it will appear as a defocused, yet natural, backdrop from which the flower will "pop."

94 | Use a Focusing Slide

When using a macro lens or a lens with an extension ring, any adjustment you make to the focusing ring will alter the image magnification. If you require a fixed magnification (for example, when taking comparative pictures for a textbook or a field guide), you can determine the amount of extension required for a given focal length lens by reading the magnification tables normally supplied with a macro lens or extension ring. If magnifications several times greater than life-size are required, insert a bellows extension between the camera and the lens.

Once the required magnification ratio, for example 2:1, has been set, neither the focusing ring on the camera nor the amount of extension should be altered. While the camera can be focused by moving the tripod towards or away from the subject, it is

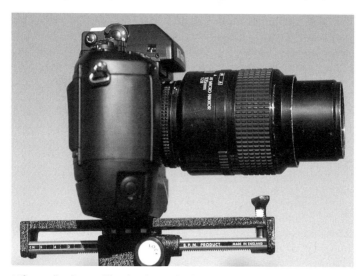

When a fixed magnification is required, mount the camera on a focusing slide to adjust the focus.

much faster—and more precise—either to use a bellows unit with a built-in focusing rail or to mount the camera on a separate focusing slide before attaching it to the tripod. Either way, the entire unit—camera, lens, and bellows—can easily be moved in or out until the subject is focused in a precise plane, without changing the desired magnification ratio, and without having to struggle with lifting and re-positioning the entire setup.

Most focusing slides are capable of moving the camera only forward or backward, but a few models have a dual-axis stage that also enables the composition to be fine-tuned by means of a sideways movement as well.

 95 | **Miniature Reflectors**

The direction, angle, and strength of the light can make or mar a macro shot. Large reflectors that are used to fill in extensive shadow areas (see Tip 49) are not suitable for close-ups—this use is akin to taking a sledgehammer to crack a peanut, and they may not direct the light precisely where you want it.

Lastolite, Westcott, and Photoflex produce a range of small collapsible reflectors (the 12-inch model is small enough to fit in a pocket). The three most useful double-sided reflectors for working outdoors come with a silver, gold, or a mix of silver and gold (called "Sunlite") on one side, and white on the reverse.

Gold can be too warm (rated at 3800° Kelvin) for pastel-colored flowers, but is good for autumn fruits or leaves, and silver (rated at 5600° K) is fine for many subjects, but my preference is for the "Sunlite" or soft gold version, which provides the most natural-looking fill (rated at 4750° K). I also use a host of makeshift mini reflectors that are cheap and easily replaceable. They include:

❑ aluminum foil folded around a piece of cardboard
❑ silver containers used for take-out food

❏ the inside of some chip bags or a helium-filled balloon
❏ a silver "dark slide" from a Hasselblad film magazine
❏ a small camping or handbag mirror

96 | Shooting Shiny Objects

Glossy camellia and holly leaves, many fruits and berries, as well as cowrie shells all reflect sunlight as a distinct highlight. Though this can be used to advantage to provide a sparkle to a few large fruits, when taking a photo of a cluster of small berries, the effect can be rather distracting. One solution is to work with soft indirect light produced by a light cloud cover, another is to place a

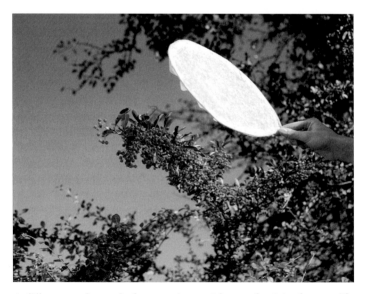

A diffuser can be made from a wire coat hanger bent to shape, with white opaque interfacing stapled onto it.

diffuser between the light source (sun or flash) and the subject (see Tip 50).

In addition to ready-made circular collapsible diffusers (made by Photoflex and Lastolite, several inexpensive materials can be used to make smaller models for close-up work. These include white diffusion filter gels, greaseproof paper, or white interfacing (dressmakers' stiffening fabric) stretched over a wire frame (a wire coat hanger, opened out) and fixed with small staples. I use medium-weight non-iron interfacing, which causes a light loss of one stop.

Translucent white nylon light tents made by Lastolite provide soft, shadowless lighting and are available in four diameters (20-, 30-, 38-, and 60-inch). The circular base rests on the ground, while the apex of the cone can either be suspended from a branch or held by an assistant. The camera can be inserted at any point between the apex and the base simply by opening a slit secured by hook-and-loop tape such as Velcro.

A variation on this light tent is a smaller, truncated cone made of white opaque Plexiglas, which I use when taking photos of shiny shells on a sandy beach or shiny fruits on a damp forest floor. This accessory also provides all-round shadowless lighting, although the top opening dictates an overhead viewpoint.

97 | Dramatic Backlighting

Shooting into the light not only adds impact to a close-up, but also helps to define surface elements, such as fine hairs or spines. Also, translucent autumnal leaves or single flowers with large petals such as poppies appear to glow when they are backlit. To visualize the shot, work early or late in the day, and utilize the low-angled sun to provide natural backlighting.

On overcast days, create your own backlighting for close-ups by using remote flash. Attach it to a flash shoe mounted on either

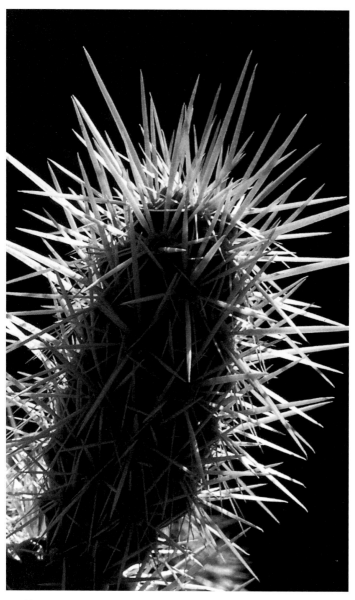

Backlighting enhances the texture of the spines on a silver cholla cactus.

a ballhead or a Bogen/Manfrotto Swivel Umbrella Adapter. Then place it on a spiked wooden pole that can be pushed into soft ground. If the ground is solid rock, a small tripod, such as a Benbo Low-Boy, can be used to support the flash.

The main problem of using a small flash that lacks a built-in modeling light is that you cannot see the final effect. However, if you tape a small flashlight to the top of the flash unit, it can give a rough indication of where the highlights and shadows will fall.

Don't forget to use a lens shade to help reduce the chance of lens flare. In a pinch, a tube of black cardboard taped around the lens can be used as a makeshift shade.

Metering natural backlit subjects need not be a problem. When taking backlit flowers or green or red leaves, I manually spot meter the light shining through the petal or leaf. With delicate plants, such as grasses, or rimlit solid subjects, I turn around 180° and manually meter the light falling on an average-toned subject—green grass or leaves work well. Beware of pastel-colored flowers and yellow leaves though, as they will give a brighter-than-average TTL reading, and so the exposure will need to be increased by 2/3 to 1 stop.

98 Enhance Nature's Textures

Surface irregularities such as ripples on a sandy beach, spines on cacti, cracked or flaked tree bark, warts and scales on animal skins, ribs on rope lava, or spines and grooves on shells give subjects texture. Some textures can be photographed year-round, such as tree barks (which make great subjects for photo essays), while others are ephemeral, such as creased leaves and large crumpled petals, which appear only as buds break. The nature of a textured surface can be appreciated—in light or darkness—by running your fingers over it.

Spines or warts that contrast in color with their background will appear conspicuous but two-dimensional when lit by soft,

diffuse light. Therefore, conveying texture in a photograph requires low-angled lighting to cast shadows, which accentuate the third dimension. Even the slightest irregularities on monotoned rocks or encrusting lichens are accentuated by holding a flash unit level with the subject's surface so that the light literally grazes it, casting shadows across its dips and depressions.

Sidelighting on pahoehoe lava in the Galapagos reveals its rope-like texture.

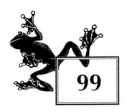

99 | Beneath the Surface

Life in shallow water—whether it be in freshwater ponds or coastal rock pools—makes for some novel through-water close-ups. Submerged plants can be taken with available light, whereas mobile fish or crabs are enhanced by using a flash. When you are working anywhere near water, make sure all the movable parts on a tripod are secure *before* attaching the camera.

Surface ripples on a large pool can be eliminated from the field of view by floating a wooden frame on the water, but you will need someone to hold it in position so that it does not drift across the picture.

Look through the viewfinder to check that there are no sky-light reflections (or for that matter, ghostly images of you, the camera, or tripod) on the water's surface. If there are, mask them

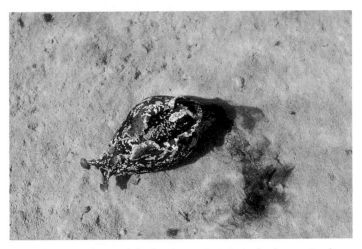

A sea hare ejecting an ink cloud was shot through clear water in a shallow lagoon in Baja California.

from the field of view either by getting someone to hold a black umbrella over the camera and tripod or by draping a black cloth over your head.

When using flash, care must be taken to ensure it is not reflected back into the camera. This means it *must* be used off-camera, preferably held to one side and angled down at approximately 45° to the water's surface.

Sedentary plants or sea anemones allow you time to appraise the composition and the position of the flash. This is more difficult with active fish, but if possible, the flash should be positioned so that it illuminates the fish's head first in preference to the tail. This prevents an obvious shadow from extending in front of the head.

100 Twin-Flash Setup

For close-ups of mobile, active subjects such as insects, flash is essential to both freeze movement and gain additional depth of field. When stalking insects on the hoof, the easiest way to work with the greatest chance of success is to carry the camera and flash units mounted together as a single unit on a flash bracket. In this situation, I abandon all my flash brackets designed to support a single flash in favor of a twin-flash boomerang-shaped bracket, made for me—appropriately enough—by an Australian photographer. Another good choice is the Lepp bracket manufactured by Stroboframe. The advantage of having a twin bracket is that a pair of flashes light a three-dimensional insect more evenly than a single flash located on one side of the camera. I mount one flash unit on either side of the camera, with the prime flash at a higher level than the fill flash. Over the fill flash I tape a layer or two of opaque diffusion filter gel to reduce the output and soften the shadows.

I first used this setup long before TTL flash units were

available; indeed, I much prefer the basic, non-TTL small flash units because they are considerably lighter than the Nikon SB-24 or SB-26. With non-TTL flash, I bracket the exposures for a given film speed at specific magnifications (1/4x, 1/2x, or life-size). As the magnification is increased, the camera and flash units are moved in closer, and this often compensates for the loss in light caused by increasing the extension on a macro lens.

A twin-flash bracket provides a convenient support for mounting the camera and two small flash units to take close-ups.

101 | Put It in Reverse

When working at magnifications of half life-size (1:2) or greater on film, reversing the lens (using a reversing ring) will not only enhance image definition, it will also increase image magnification. For example, when focused at its shortest distance, a 55mm macro lens has a reproduction ratio of 1:2, however, it is increased to 1.1:1 when reversed.

However, as with many aspects of photography, no benefit is gained without cost. When a lens is reversed, it loses all meter and aperture coupling. Therefore, it either has to be stopped down manually, or else a Z-ring (automatic diaphragm ring) must be fitted to the back of the lens (remember, this is now at the front) and a twin cable release used (this accessory simultaneously closes the diaphragm and releases the shutter).

Also, you cannot fit a lens shade to the back of a lens. Fortunately, there is a ready-made substitute, namely a small extension ring. This can be attached to the rear of the lens or Z-ring, where it will function as a rigid lens shade. Before taking the picture, stop the lens down to the selected aperture to check that there is no vignetting at the corners of the frame. And if you are really stuck for a shade, you can always wrap a tube of matte black paper around the lens.

TIPS AND HINTS
RESOURCES

(Products in bold are cited in the text.)

Beattie Systems, Inc.
P.O. Box 3142
2407 Guthrie Avenue
Cleveland, TN 37311, USA
Tel: (423) 479-8566
(800) 251-6333
Fax: (423) 476-6171
Beattie Intenscreens

Cameramac
55 Hodge Bower
Ironbridge
Telford TF8 7QE, England
Tel/Fax: +44 (0)1952 433271
*Made-to-measure **waterproof covers** for camera complete with lens*

Niall Benvie
24 Park Road, Brechin
Angus DD9 7AP, Scotland
Tel/Fax: +44 (0) 1356 626 128
Ben-V beanbags *with straps*

Cascade Designs Inc.
4000 1st Avenue South
Seattle, WA 98134, USA
Tel: (800) 531-9531
Fax: (206) 467-9421
Packtowl, *which absorbs water nine times better than terrycloth*

Bogen Photo Corporation
565 East Crescent Avenue
Ramsey, NJ 07446-0506, USA
Tel: (201) 818-9500
Fax: (201) 818-9177
Bogen *and* ***Gitzo*** *tripods, heads, and monopods,* ***Gitzo tripod leg covers****, and a wide range of Bogen lighting accessories*

Fisher Space Pen
711 Yucca Street
Boulder City, NV 89005, USA
Tel: (702) 293-3011
(800) 634-3494
Fax: (702) 293-6616
Fisher Space Pen*, which writes in any climate and on almost any surface*

Kirk Enterprises
107 Lange Lane
Angola, IN 46703, USA
Tel: (219) 665-3670
(800) 626-5074 (U.S.)
Fax: (219) 665-9433
*Quick-release plates for every
major camera and their long
lenses, multi-purpose window
mount, lens mount for 80-
200mm f/2.8 AF Nikkor lens,
flash brackets, drop-in polariz-
ers for long Nikkor lenses,*
Low Pod, Hugger™ beanbags,
and **N-visi/Bag** *blind*

A. Laird Photo Accessories
P.O. Box 1250
Red Lodge, MT 59068, USA
Tel: (406) 446-2168
Fax: (406) 446-2513
**Tri-Pads®, Laird Rain
Hoods®,** *and* **Macro Ground
Cloth**

Lastolite Limited
Unit 8, Vulcan Court
Hermitage Industrial Estate
Coalville
Leicestershire LE67 3FW
England
Tel: +44 (0) 1530 813381
Fax: +44 (0) 1530 830408
Lastolite *reflectors and diffus-
ers;* **Stronghold** *camera bags
with Procam® frames inside*

Tory Lepp Productions
P.O. Box 62424
Los Osos, CA 93412, USA
Tel/Fax: (805) 528-0701
Project-A-Flash *for increasing
flash output with long lenses*

Manfrotto
Calumet Trading
P.O. Box 3128
Tilbrook
Milton Keynes, MK7 8JB
England
Tel: +44 (0) 1908 646444
Fax: +44 (0) 1908 646434
*U.K. distributor of Manfrotto
products*

Monostat AG
Chilefeldstrasse 17
CH-5634 Merenschwand
Switzerland
Tel: +41 (0) 77 645575
Fax: +41 (0) 56 6645988
Monostat *monopods with
swivel-toe base (see also
Photographica)*

Olympus America Inc.
2 Corporate Center Dr.
Melville, NY 11747
Tel: (516) 844-5000
Fax: (516) 844-5262
Olympus Note Corders

Photoflex Inc.
333 Encinal Street
Santa Cruz, CA 95060, USA
Tel: (408) 454-9100
(800) 486-2674
Fax: (408) 454-9600
Flash modifiers, diffusers, and
Litediscs

Photographica
45-1548 Richmond Street
London
Ontario N6G 4W7, Canada
Tel: (519) 858-0443
Fax: (519) 858-0449
Distributes **Monostat** *mono-pod*

Quantum Instruments
1075 Stewart Avenue
Garden City, NY 11530, USA
Tel: (516) 222-0611
Fax: (516) 222-0569
Battery packs and radio slave units

Really Right Stuff
P.O. Box 6531
Los Osos, CA 93412, USA
Tel: (805) 528-6321
Fax: (805) 528-7964
Mounting plates, clamps, braces and flash arms for use with Arca-Swiss style quick-release system

Recreational Equipment Inc.
(REI)
1700 45th Street East
Sumner, WA 98390, USA
Tel: (206) 891-2500
(800) 426-4840
Fax: (206) 891-2523
Specializes in mountaineering and camping gear: **River-packs,** *mesh stuff bags, outdoor clothing, etc.*

Rosco Laboratories Inc.
52 Harbor View Avenue
Stamford, CT 06902, USA
Tel: (203) 708-8900
Fax: (203) 708-8917
Rosco filters, reflectors, *and* ***diffusion gels*** *for the film and photo industry*

Leonard Rue Enterprises
138 Millbrook Road
Blairstown, NJ 07825-9534
USA
Tel: (908) 362-6616
(800) 734-2568
Fax: (908) 362-5808
Many useful items for outdoor photographers, including blinds (pop-up and portable), gunstocks, and Groofwin pod supports

The Saunders Group
21 Jet View Drive
Rochester, NY 14624, USA
Tel: (716) 328-7800
Fax: (716) 328-5078
*Benbo tripods and **EWA-
Marine** underwater housings,
Domke camera and lens bags
and protective wraps, **OutPack
Photo Backpack** and **Scope-
PACK**, and **Stroboframe** flash
brackets*

Sto-Fen
Box 7609
Santa Cruz, CA 95061, USA
Tel: (408) 427-0235
Fax: (408) 423-8336
*Light modifiers, **Omni
Bounce**, and **Two-Way
Bounce***

TreePod Inc.
P.O. Box 7548
St. Cloud, MN 56302, USA
Tel: (320) 240-2362
Fax: (320) 654-1549
***TreePod**, a novel camera or
flash support with panhead
and rotational arms*

Joseph Van Os
Photo Safaris Inc.
P.O. Box 655
Vashon Island, WA 98070
USA
Tel: (206) 463-5383
Fax: (206) 463-5484
*Worldwide wildlife photogra-
phy tours and photo work-
shops*

F.J. Westcott Co.
1447 Summit Street
Toledo, OH 43604, USA
Tel: (419) 243-7311
Fax: (419) 243-8401
*Lighting accessories, **Apollo,
Scrim Jim,** and **Illuminator
Reflectors***

Wildlife Watching Supplies
Town Living Farmhouse
Puddington, Tiverton
Devon EX16 8LW, England
Tel: +44 (0) 1884 860692
Fax: +44 (0) 1884 860994
*Camouflage materials, includ-
ing "pop-up" blind, **elastic
camouflage sleeving** for
lenses, scrim and leaf screen,
tripod slings*

Notes